VISIONS OF ILLINOIS

A series of publications portraying the rich heritage
of the state through historical and contemporary works
of photography and art

ON SECOND GLANCE

On Second Glance

MIDWEST PHOTOGRAPHS
BY LARRY KANFER

FOREWORD BY WALTER L. CREESE

University of Illinois Press | *Urbana and Chicago*

© 1992 by the Board of Trustees of the University of Illinois
Photographs © 1992 by Larry Kanfer. These images may not be used
for commercial purposes without the consent of the photographer.
Manufactured in the United States of America
C 5 4 3 2 1
This book is printed on acid-free paper.

Library of Congress Cataloging-in-Publication Data appear at the
end of this volume.

FOREWORD

For those desirous of taking in the landscape at large, Larry Kanfer has furnished a second glance. This collection, as intriguing as *Prairiescapes,* published in 1987, offers another unmatched opportunity to enjoy the self-renewing, seasonal spectacle of the prairie.

Kanfer rivals the prairie scene itself with his economy of means. Occasionally, his message depends on a single motif—a church erupting out of a cornfield (33) tests our credulity—but mostly he is content with focusing on two motifs in a field: a barn and a tree (13), or a fence and a tree (27). At times he appears to go to ground zero, through the slight upward curve of open fields (24, 25), or else he occupies himself with fugitive bits of memory, like the paint chipping off or fading from a barn wall or door (22, 23).

The prairie is extraordinary by virtue of being so uninterrupted, lacking a complement of mountains, natural lakes, thick forests, and swiftly running streams. The lasting delight for the spectator therefore depends on bringing to the surface more than he or she expects by better comprehending the earthly language. Larry Kanfer's vision may best be explained by comparing it to that of other American authors of landscape, planning, and architectural analyses of the public domain. Fundamental to their visual inquiry is the deep-seated environmental protest typical of the sixties. Representative of this protest was Peter Blake's *God's Own Junkyard: The Planned Deterioration of America's Landscape.* (The term "America's landscape" was used generically, for what most worried Blake was the in-town and suburban misuse of the landed heritage.) A frequent subject in his pictorial survey is the commercial strip, often condensed by a telephoto lens, with its bevy of large advertising signs, liquor stores, motels, old car depots, and gas stations. *God's Own Landscape* was an immediate sensation with the media and with public officials. In fact, I remember one governor drumming his fingers on the book's cover as he asked me what could

be done about the highway commercial strip, which he renamed "The Ten Miserable Miles," along his state's most enthralling coastal stretch.

Beyond *God's Own Junkyard,* theory bifurcated. One methodology aimed at sorting out by symbols the canyon streets and their surrounding density, as represented by Kevin Lynch's analysis in *The Image of the City.* Lynch was a professor of urban planning at the Massachusetts Institute of Technology, and his book reflects the institute's perfection of computers and electronic communication and its desire to rapidly collect and sort quantities of information. It became a welcome how-to-see-it manual for students and practitioners alike. According to Lynch, the book was intended to serve as "a short-cut method for eliciting the public image in any given city."

The other methodology was infused with humorous irony. Robert Venturi led his Yale architectural class westward in 1968, and from that expedition came the famous *Learning from Las Vegas.* Venturi's class studied The Strip with great care, making extensive photographic notation that appeared in the book. Venturi reported that he had acquired one of his two key concepts, the "duck" building—an overdeveloped symbolic unit that contrasted with the "decorated shed" common to Las Vegas—directly from *God's Own Junkyard.* Las Vegas's long avenue of signage, bright lights, and exotic casinos was also poetically reincarnated by the architect Charles Moore and the gifted luminist Richard Peters in the too-little-known "Wonder Wall" of the Louisiana World's Exposition of 1984. The wall was pictorially illuminated with successive "painted" and "syncopated" patterns of artificial light on false building fronts, everything outlined in "a play of brilliants."

To understand better the contributions of Larry Kanfer's photographs, their fresher, quieter, more settled vernacular quality, it is useful to keep in mind that Blake, Venturi, and others shaped their continental stratagems in a hectic atmosphere of 1960s ferment. Kanfer's visual-

izations, however, are never indicative of a flurry of activity. Along his peaceful country roads there are no billboards or franchised food outlets, no taller and wider buildings; and, despite titles like "Filling Station," "Service Station," and "Self-Serve," no operating gas stations. His unmodern sense of time appears to come to a nearly complete pause in a vast space. It is uniquely possible to draw a long, refreshing, contemplative breath in these pictures, as with the distant, engaging reveries of "As Time Goes By" (53) and "Emerald City" (32). In them, softer spring arrives once more!

To be sure, Kanfer has also had to cope with a hard-edged and constrained environment. He muses on gates, fences, roads, and the parallel tracks of the railroad, dividing the world into neat halves, as do the interstate highways. He gives relief as he can, with pictures like "Ice Fence" (26), the barbed wire insulated with a coat of ice so that we can look through it unharmed at quiescent fields beyond; or "Philo Bound" (70), which cuts keyholes between the Southern Railroad hopper cars so the lovely, blooming sunset, so fragile and transient, can be fully enjoyed against the dark, nearly blank cars before they move on.

The layout of the land that Kanfer is called upon to interpret is likewise rigid, orthogonal, uniform. It was once the proverbial American clean slate, rationally squared off because of the equality Thomas Jefferson wished to have extended westward to his ideal citizen, the agrarian yeoman. The Northwest Land Ordinance and Survey of 1784–87 incorporated that wish, from the Ohio River north and west. Townships six miles square, divided into thirty-six sections, were then assigned in equal quarter sections, farms of 160 acres, smaller grids developed within the supergrid—a working landscape from the outset. No western backpackers would hike these roads and fields, no sleeping bags would be placed between the corn rows at night, no float boats would shoot the drainage ditches at high water. The common sight of ridges and furrows in the fields (37, 57) tells the story: the flat length of rich earth has been repeatedly curried and brushed by the large-size machines of McCormick, Deere, Harvester, Case, and Massey-Ferguson, designed primarily for that special task and this region.

Magically, Kanfer escapes these geometric, politicized, technical limitations. "New Year's Daybreak" (40) finds him alone on the prairie, with a great, gray, V-shaped cloud above that appears to be ruminating, Janus-like, over the year past and the one to come. Meanwhile, "real" white barns and black silhouetted trees of customary size shrink to relative inconsequence. Unlike the 1960s architectural and planning philosophers, Kanfer never assumes that buildings have to have first priority. They take their own chances in this milieu.

Larry Kanfer's developed consciousness of the domelike quality of the prairie sky is evident in the roiling, awesome cold front in "Stormbound" (41); or his consciousness may resound to bare whispers, as when we look at what we supposed was an empty sky in "Cross-Country" (25), only to discover vapor trails from two jets fleeing in opposite directions to distant metropolises.

Even when he does not dramatically feature the sky, Kanfer remains as neutral toward towns as he does toward buildings. In the bucolic glance over the ground plane of "Flatville" (18), the promise of a village is acknowledged by the spire of the large Germanic brick church, of which there are only a few remaining in Central Illinois, but the expected village does not materialize. Under a gray-blue sky, undramatic, it instead remains a scatteration of small white structures across the warm, deep-piled carpet of yellow-orange, ochre, and green. This is a particularly fine prairie picture because, like the prairie itself, it shows no intention of finishing off, inside or outside the frame.

In "Fallen Fence" (51) we first see nothing more than one of those secretive grass lanes, going nowhere, that farmers leave among their stands of corn, according to the waiting drainage pattern. But then we discover that the title alludes to previously unnoticed posts lying in the immediate foreground. Sufferance of the sawing down and debris filling of Osage orange hedgerows and road ditches reappears as a thinner tolerance of youth in "Rambling" (68). The country road is quietly empty except for an afternoon shadow—or so it seems. Then we see a shiny ribbon traced in the shadow, snaking toward a metal grain bin on the left, that evinces the skid mark of a drag-racing, night-roving adolescent. Which, we must wonder, will eventually dominate: the singular shriek of tires in the night; or the farsighted, long-term serenity, and the wholesome freedom to circulate in it, that the prairie so democratically offers?

Walter L. Creese

PREFACE

When I was a child, I took a train trip with my parents from our home in Oregon to the East Coast. It was late in the summer, and during the long ride I remember seeing endless oceans of tall brown corn as we crossed through the Midwest. Traveling along at more than sixty miles an hour, all I could really see was that corn, and I wondered what it was hiding from view. I knew there must be life out there, but I couldn't see it.

In 1973, when my family moved to Illinois, I had the opportunity to discover for myself just how special the Midwest is. The beauty that surrounds us in this part of the country is so subtle that it can go unnoticed—unless we stop long enough to look around and take it all in. There are no grand gestures, just little things that, combined, create a certain splendor. The changes, focused along the horizon, are constant; they are governed by the seasons, the weather, or the cyclical nature of farming—or by all three at once. There is a sense of stability here, and the assurance that life and its routines will endure the storms that pass through.

What I hope to convey to those who view my photographs—and what is most pleasurable to me—are the challenges and rewards of discovering a tenuous beauty in the repetition of endless stands of corn and soybeans, in farm buildings huddled under a towering thunderstorm, in the momentary play of shadows. When I go out to take photographs, I seldom have a preconceived notion of what I'll be shooting. Instead, I head off in one direction or another and literally scan the horizon, hoping for a serendipitous encounter with nature. When a storm is brewing and most people are heading for the comforts of home, I head out of town and try to capture the awesome spectacle in a photograph. On a cold winter morning or a warm summer evening, I may drive along deserted country roads and take in the incredible ways light and weather can change the most ordinary of physical landscapes.

Is it possible to capture the subtle beauty of the heartland via a two-dimensional medium? I think it is, and it is my goal with each of my photographs. Compositionally, I try to draw the viewer into the picture; I want to share the mood evoked by the quiet elegance of the region. Everyone should look around, carefully and more than once. A quick look will not reveal everything in these images, just as a quick look—out your car window while traveling down the interstate—will not allow you to see the beauty that surrounds you. It is the second glance—and the third—that will help you to appreciate the Midwest. And it is the opportunity for a second glance that I share with you in this collection of photographs.

Larry Kanfer

ON SECOND GLANCE

Look for the stars, you'll say that there are none;
Look up a second time, and, one by one,
You mark them twinkling out with silvery light,
And wonder how they could elude the sight!

—William Wordsworth

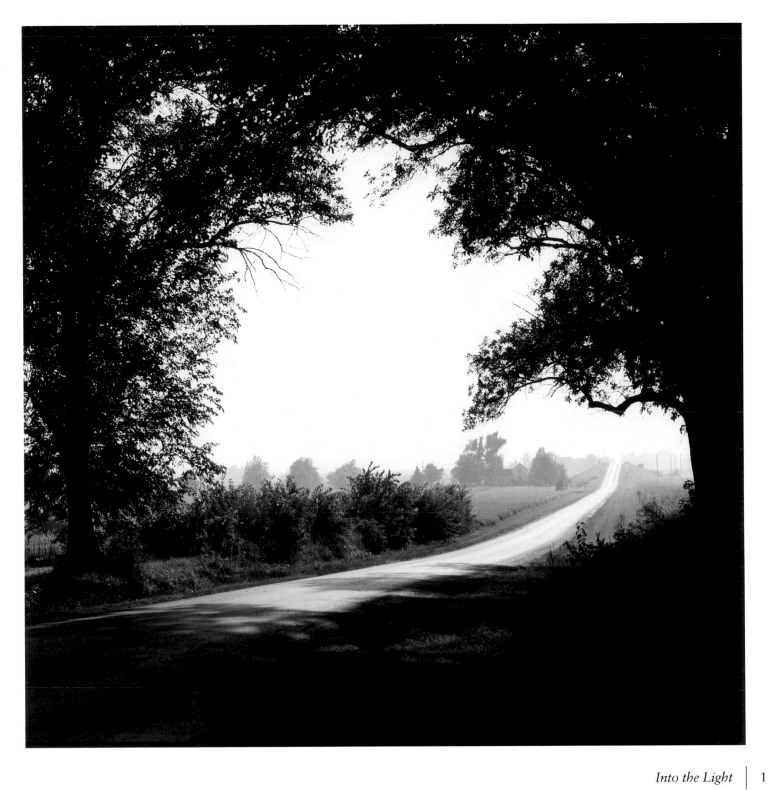

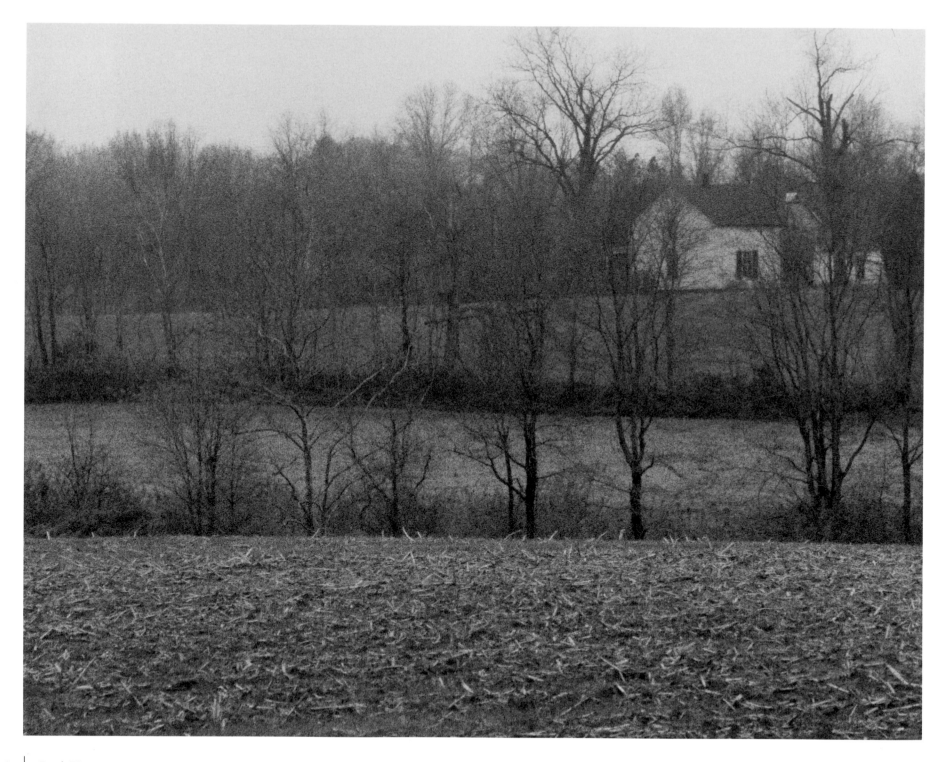

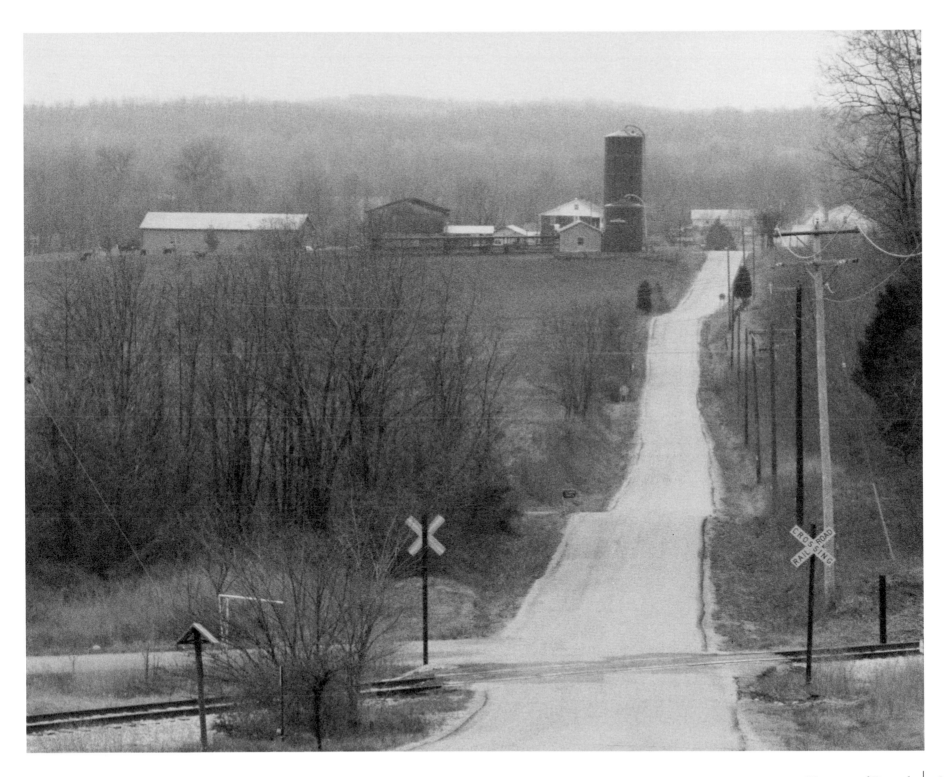

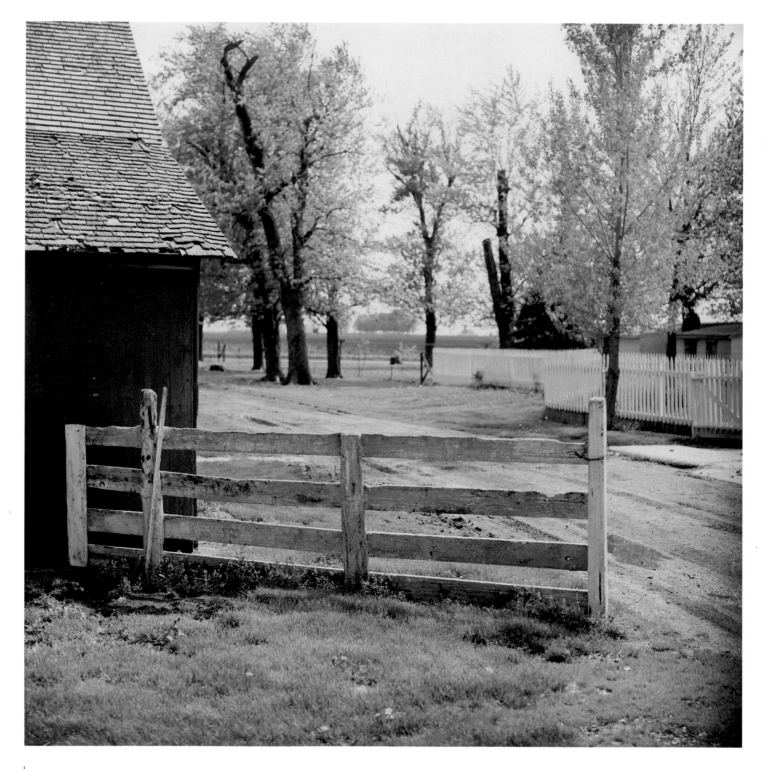

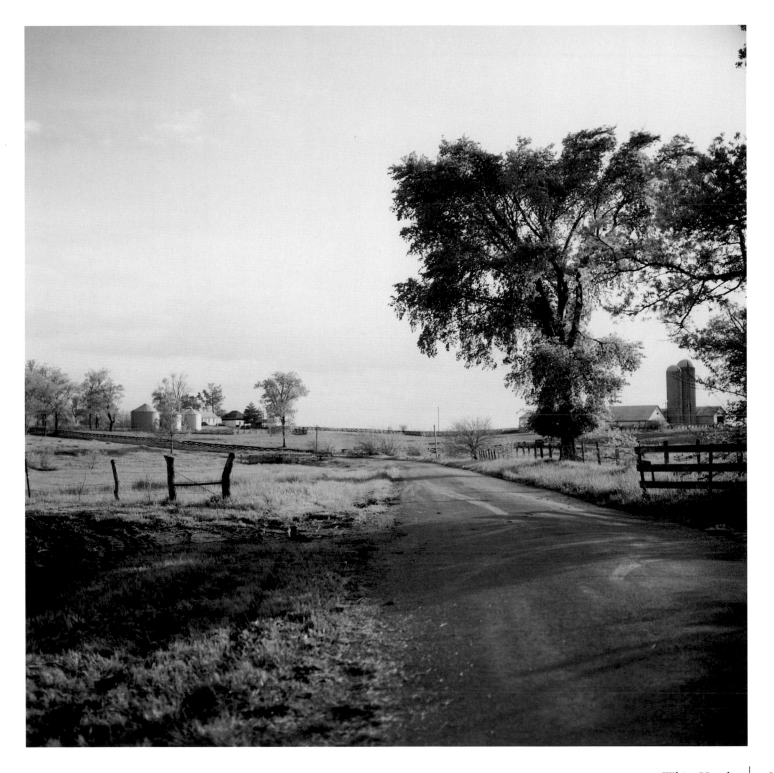

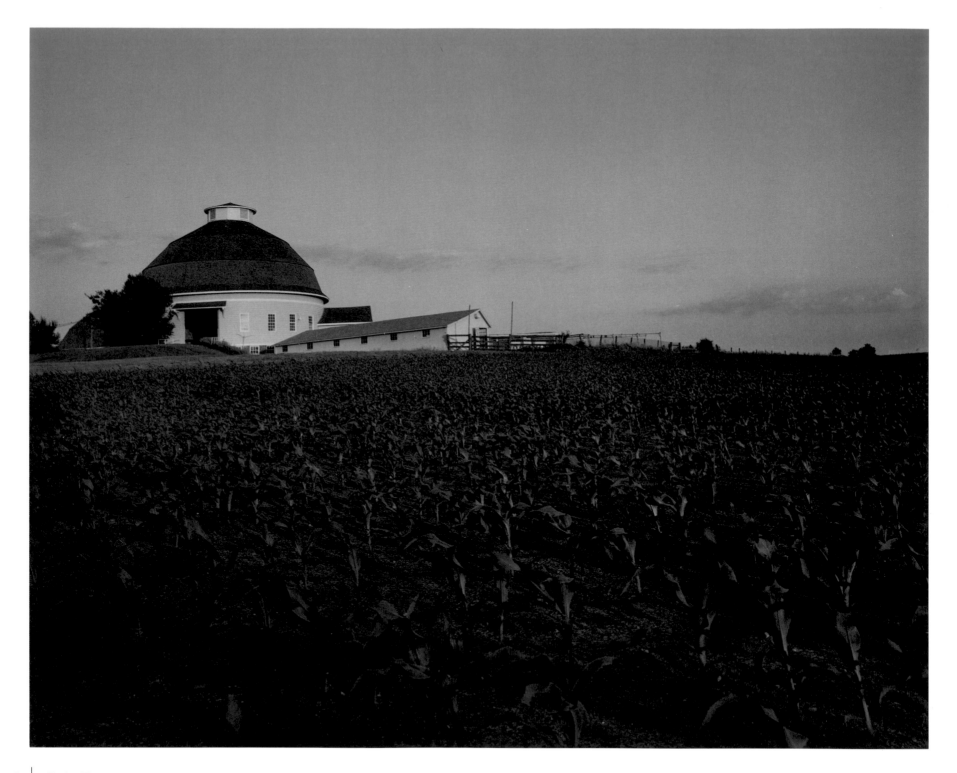

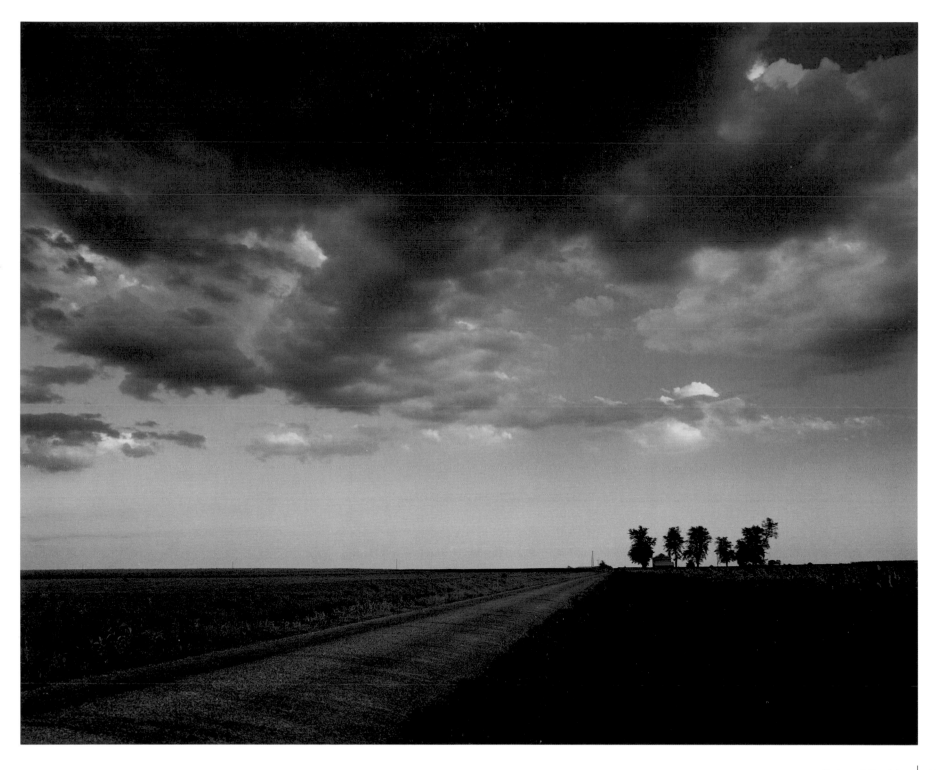

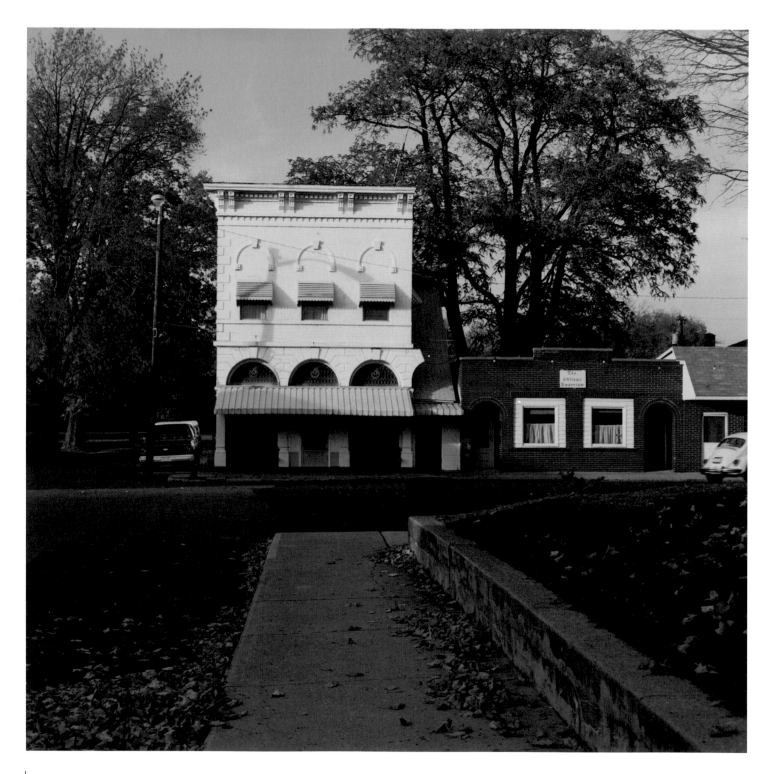

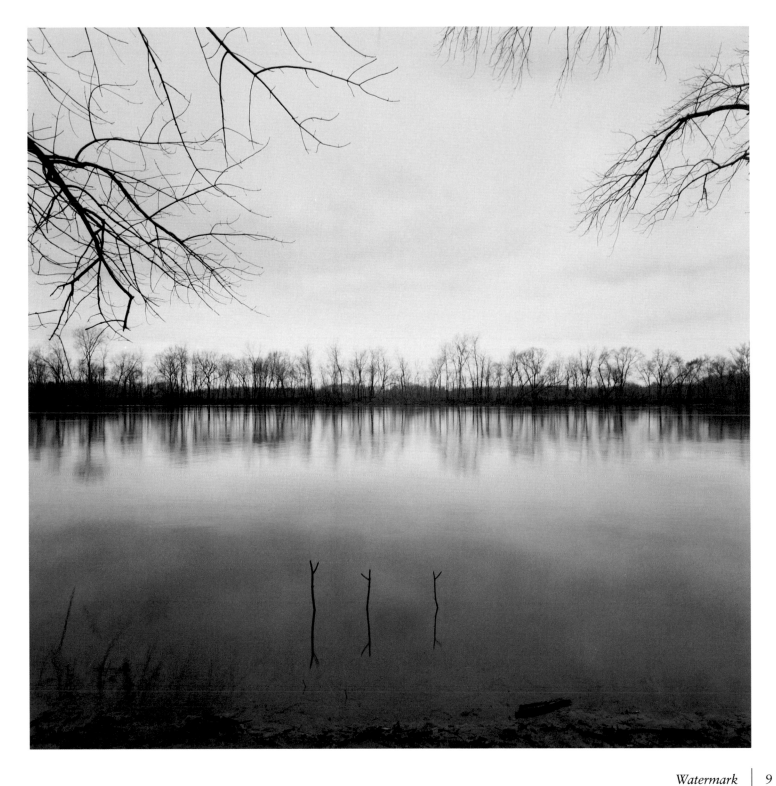

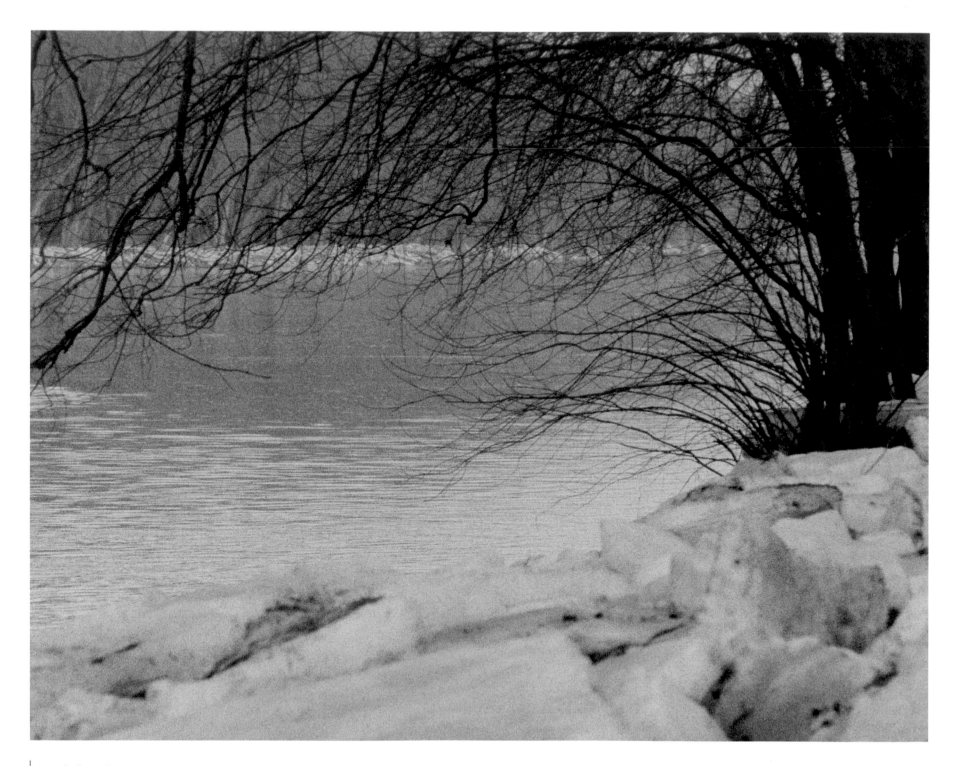

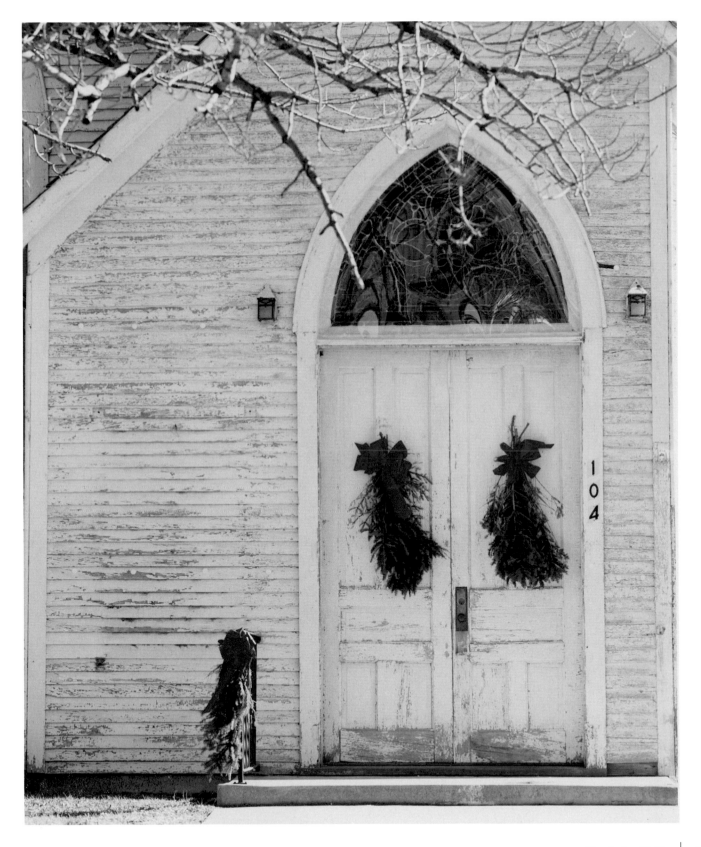

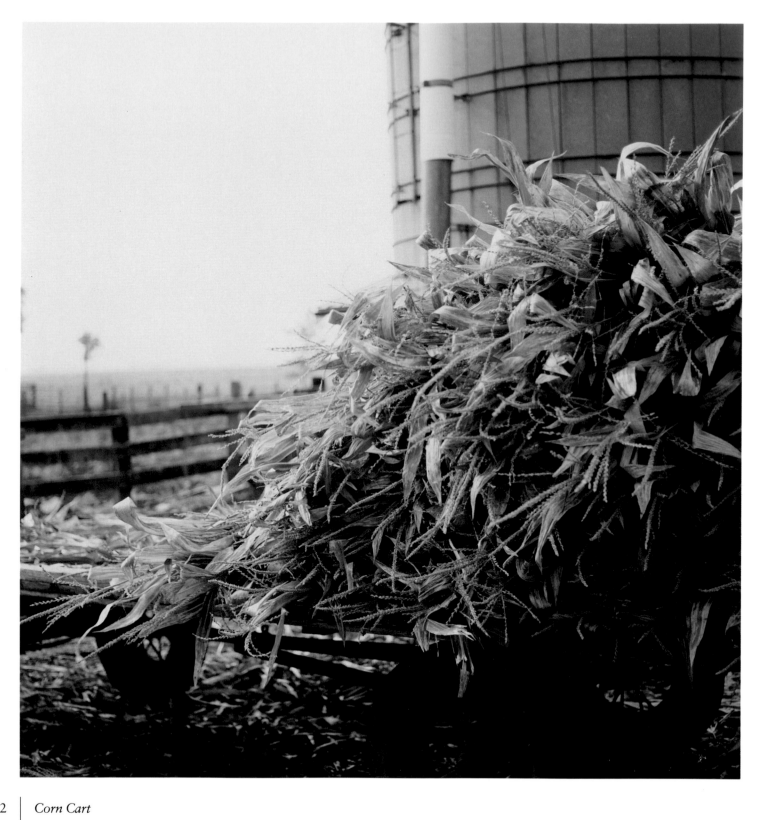

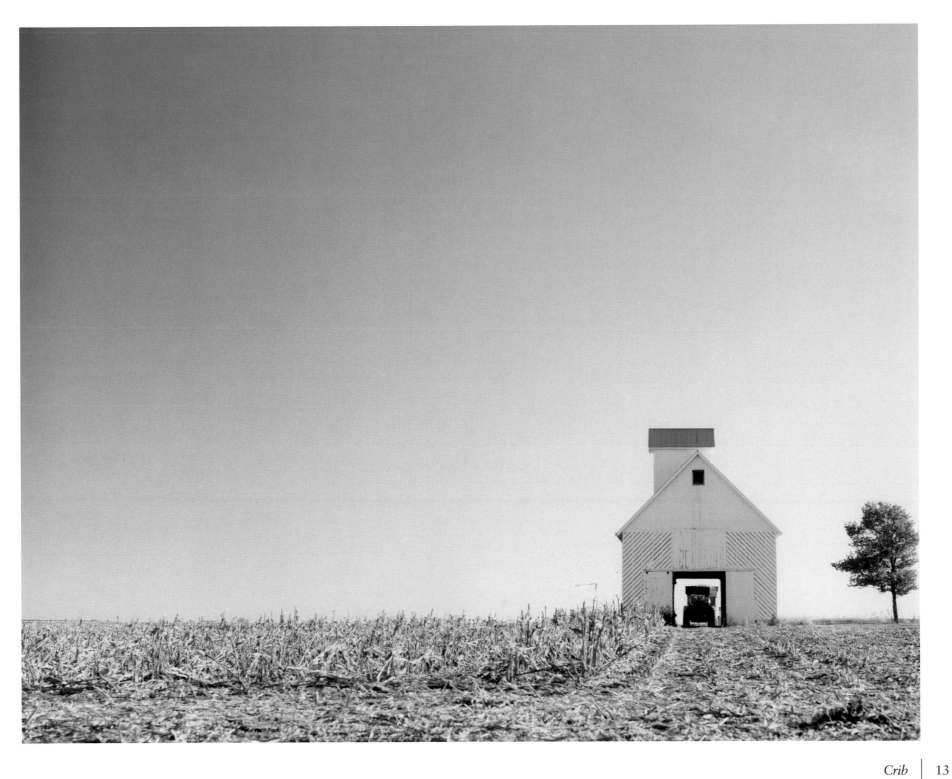

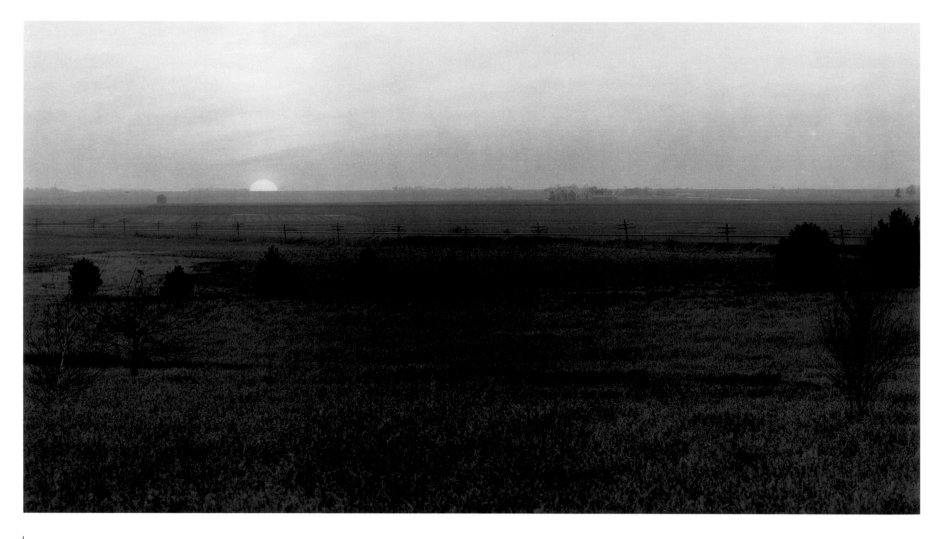

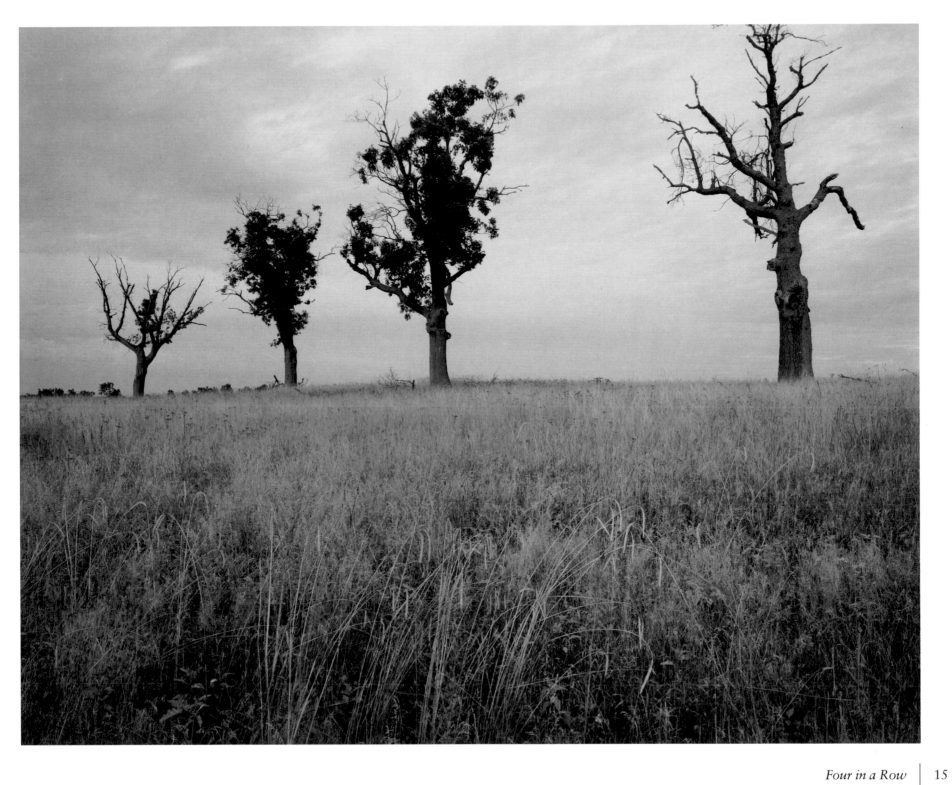

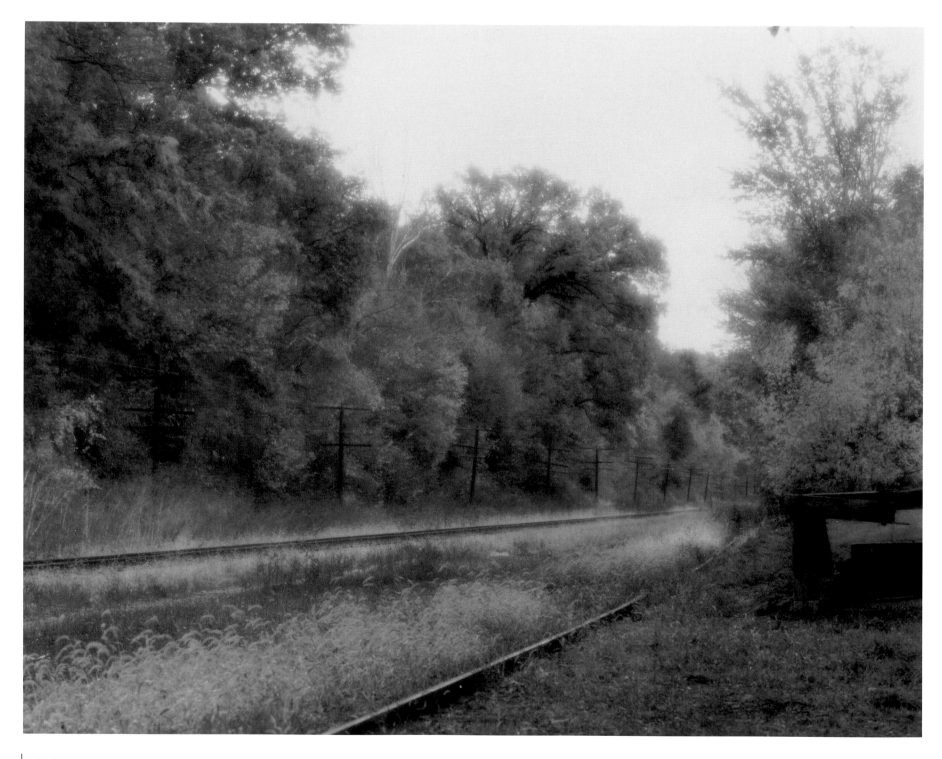

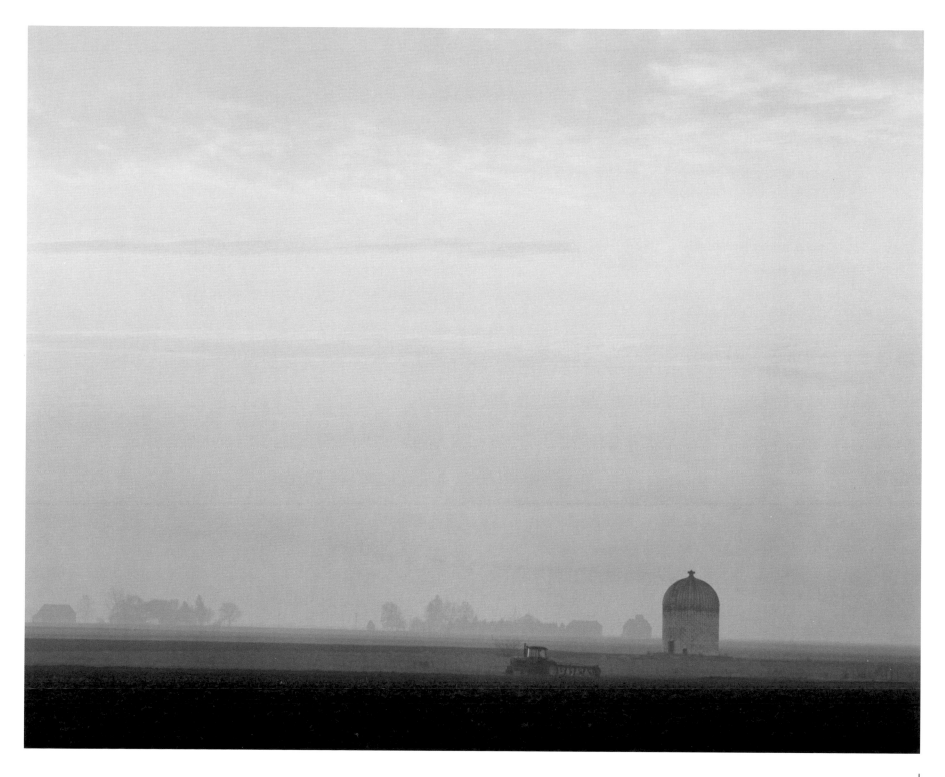

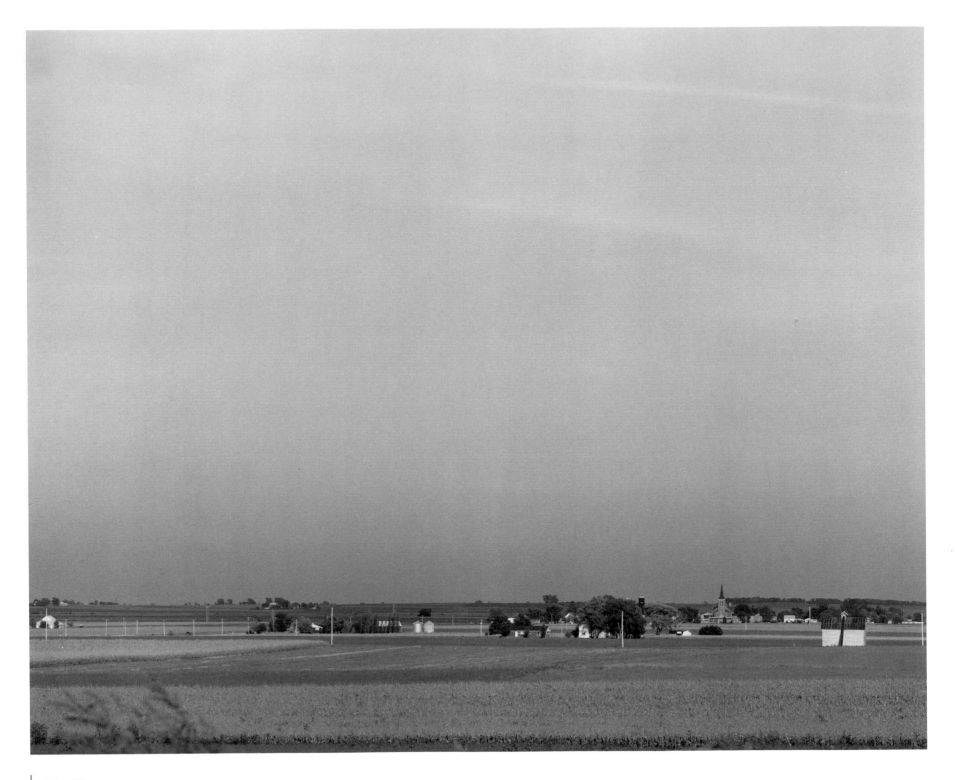

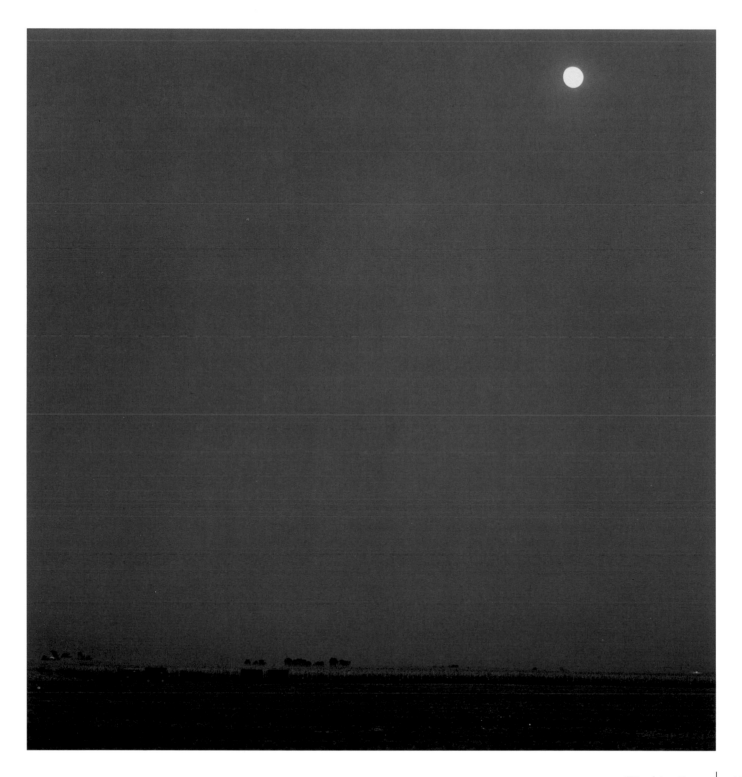

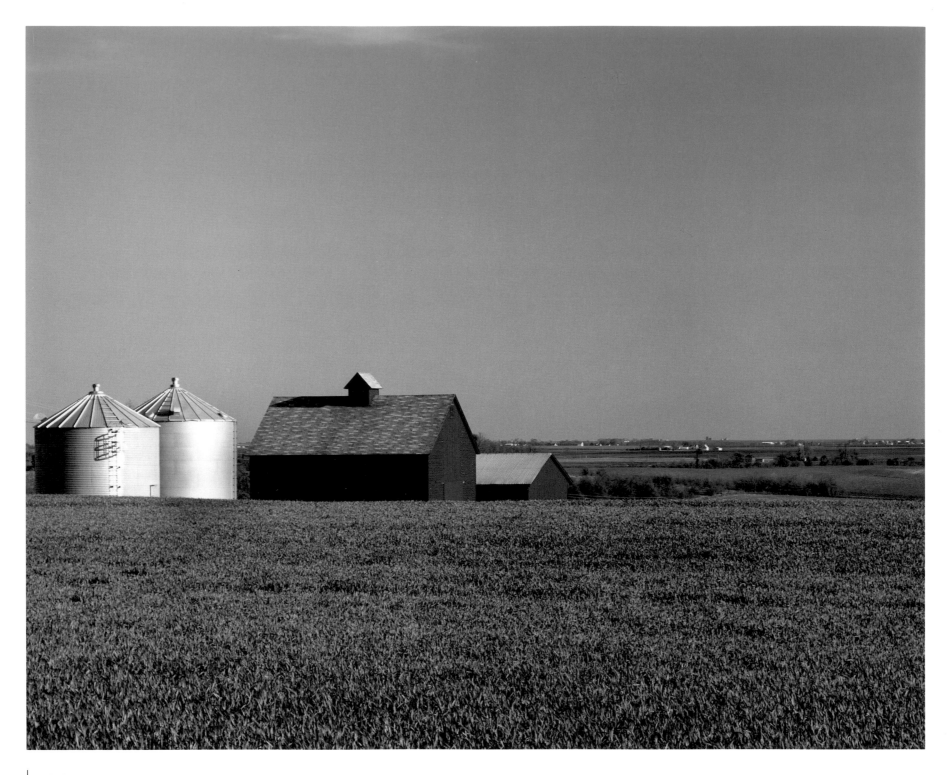

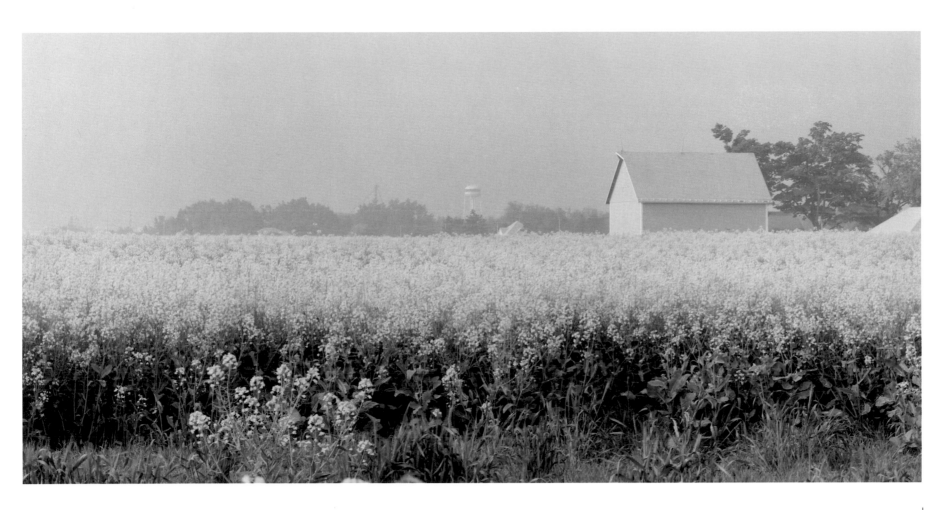

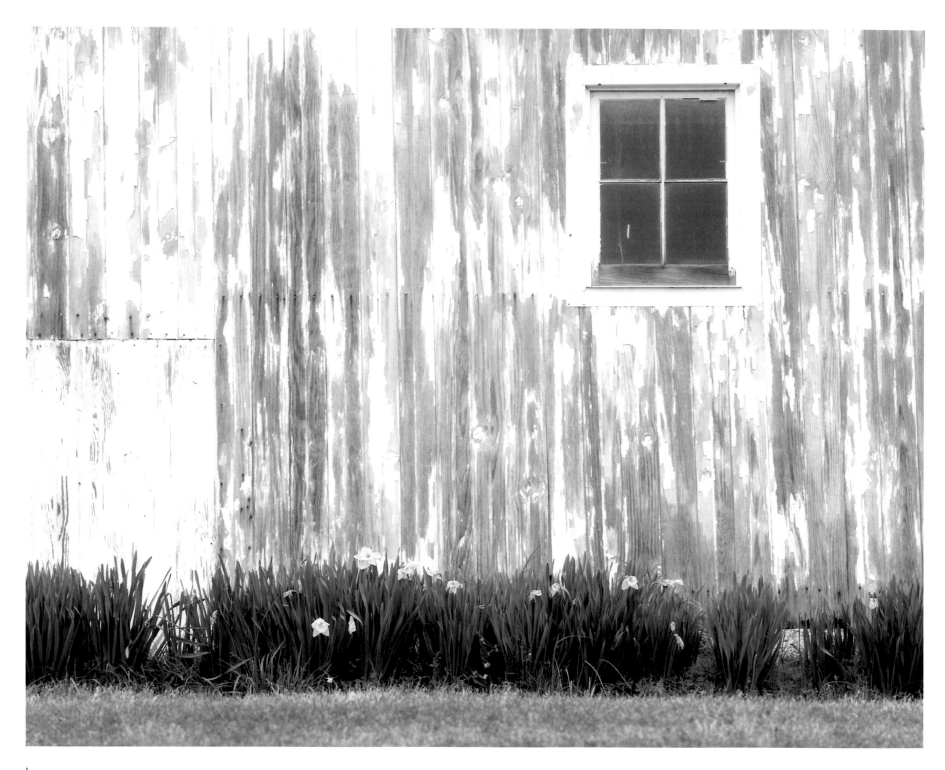

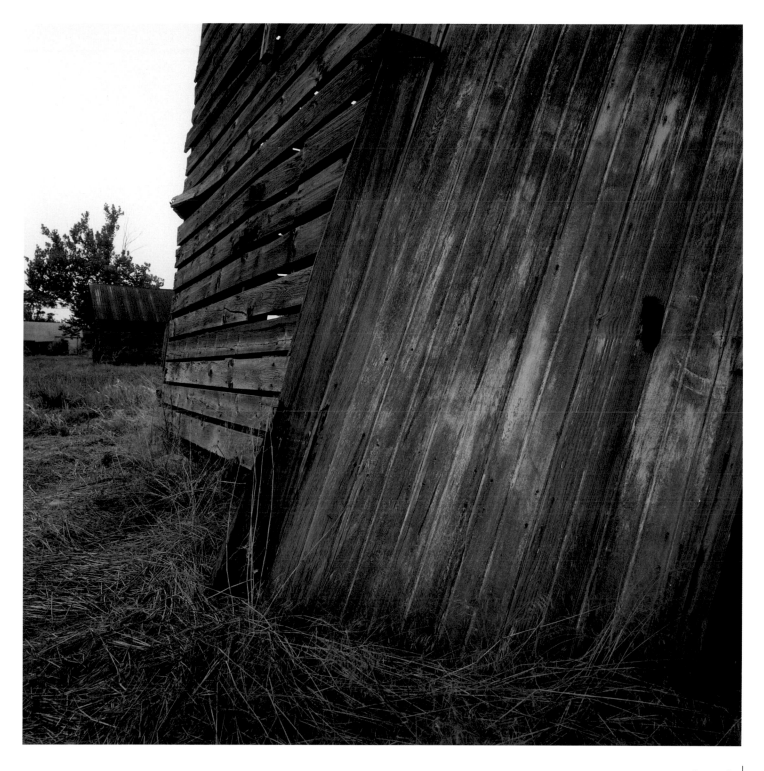

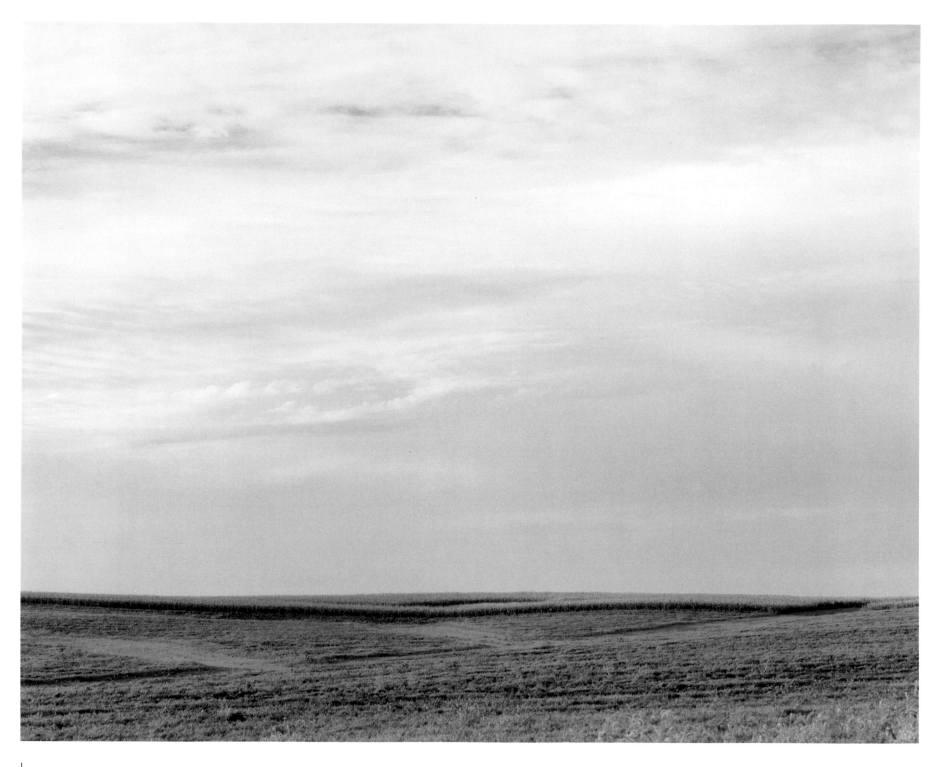

24 | *Undulations*

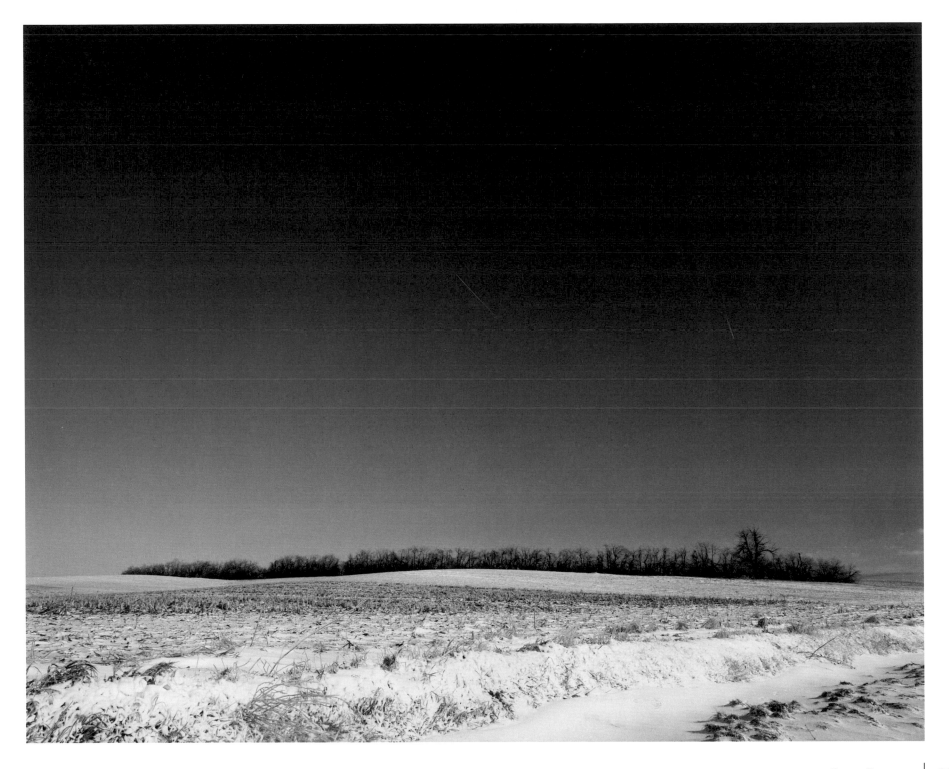

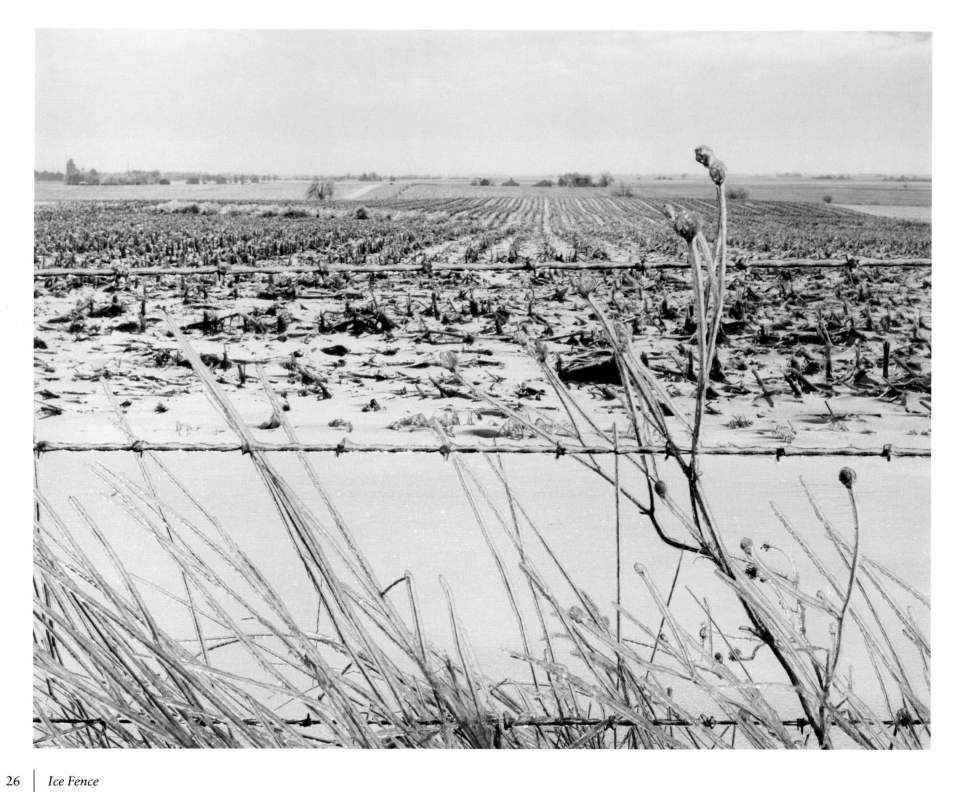

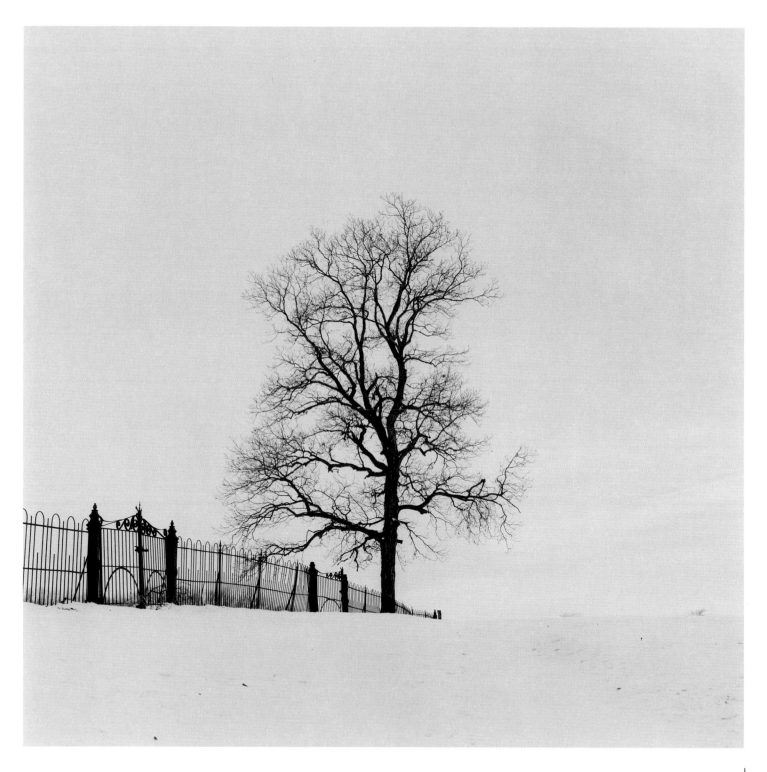

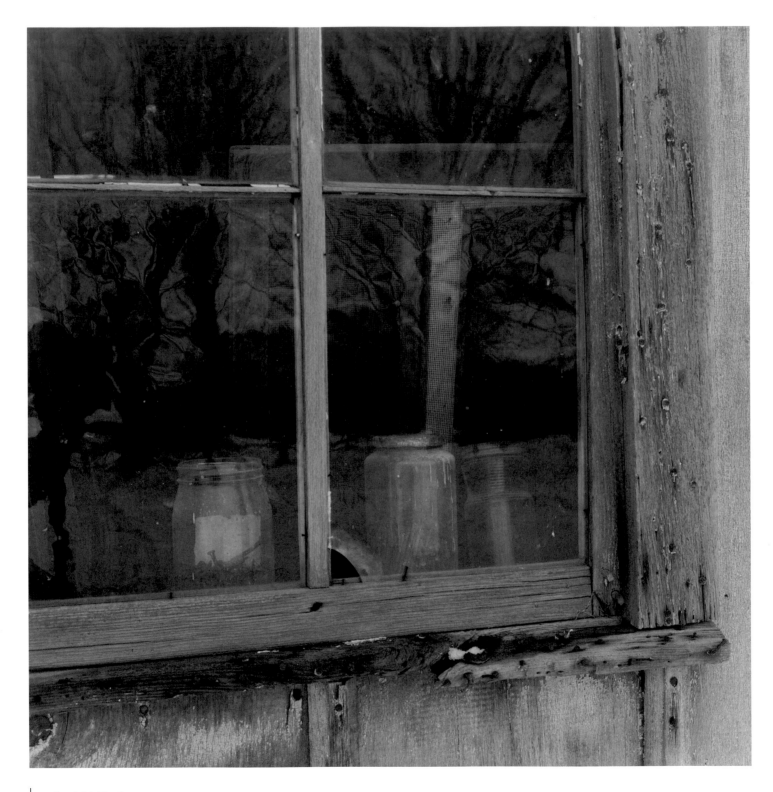

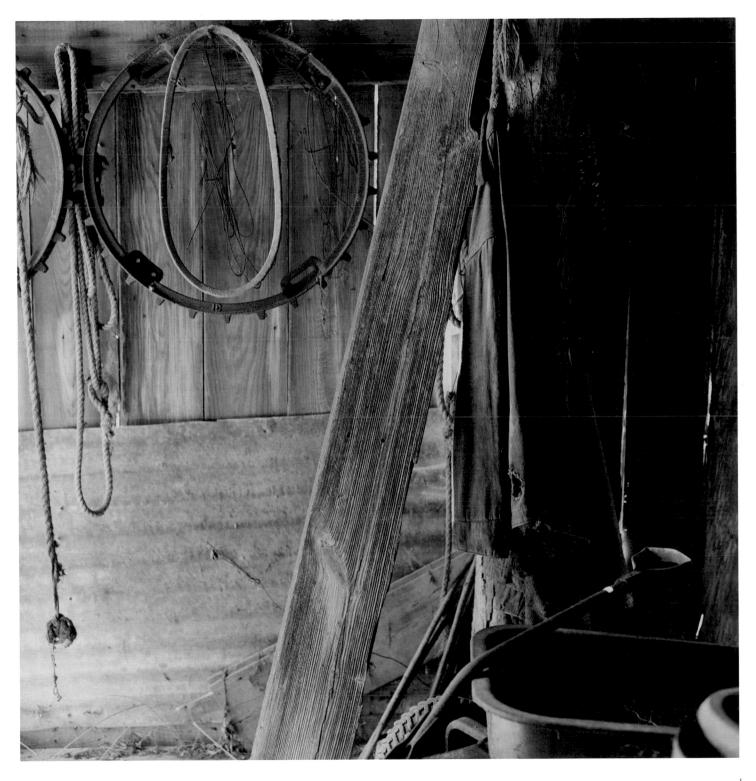

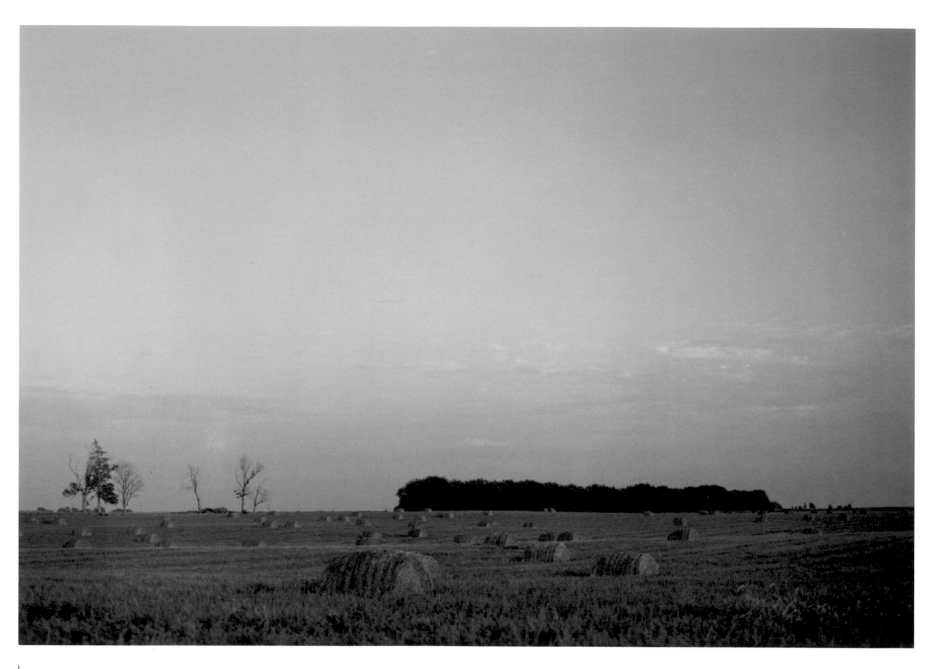

30 | *Bales*

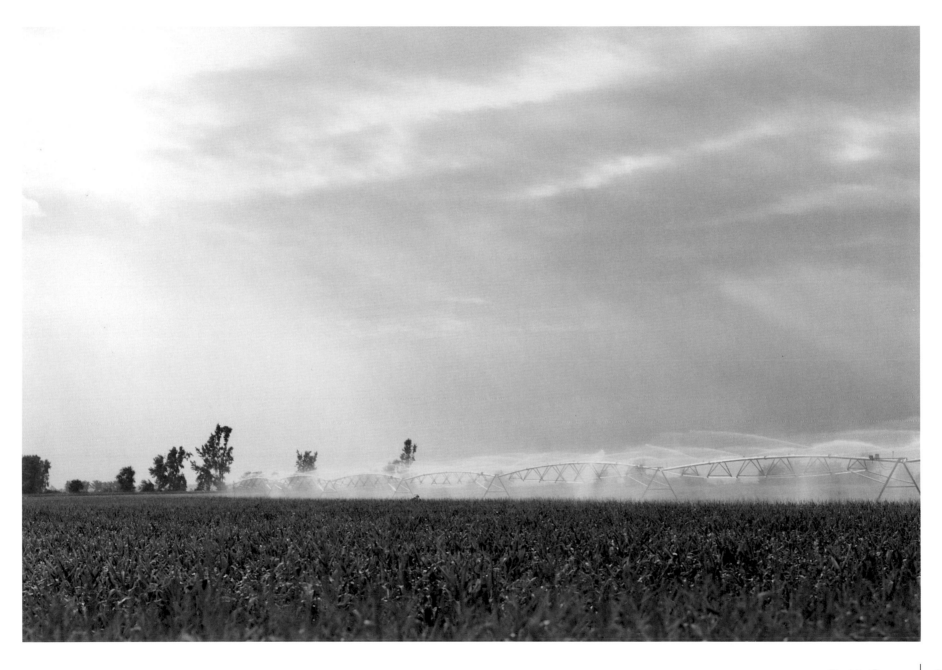

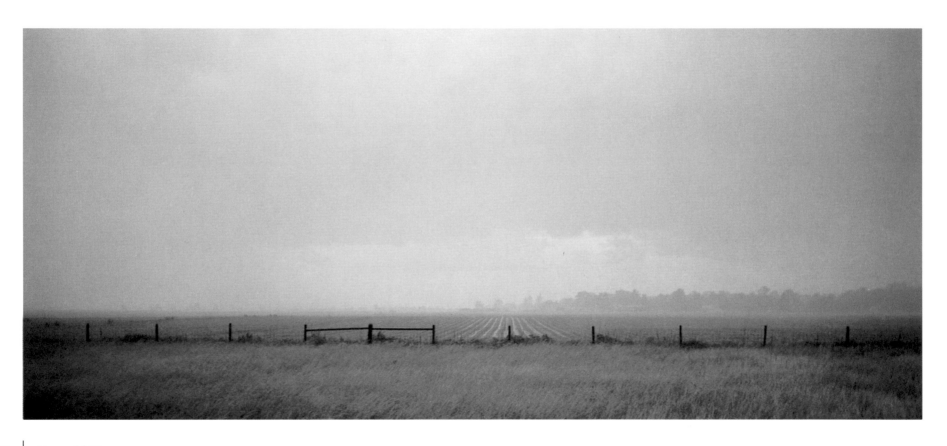

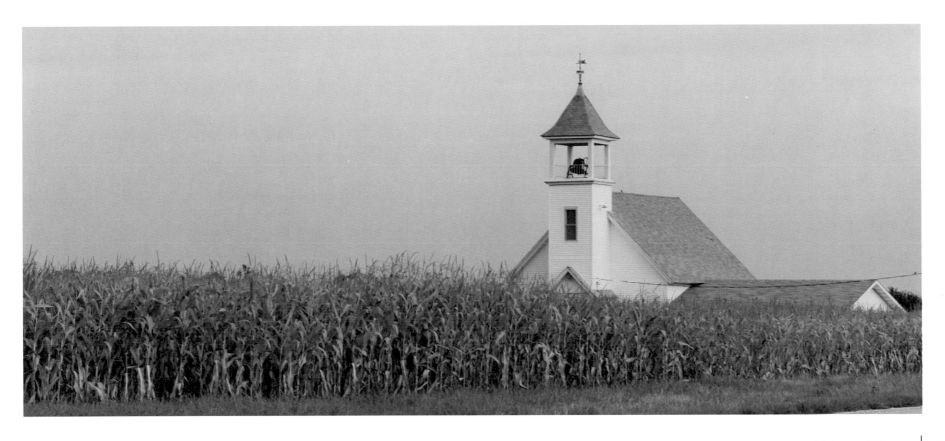

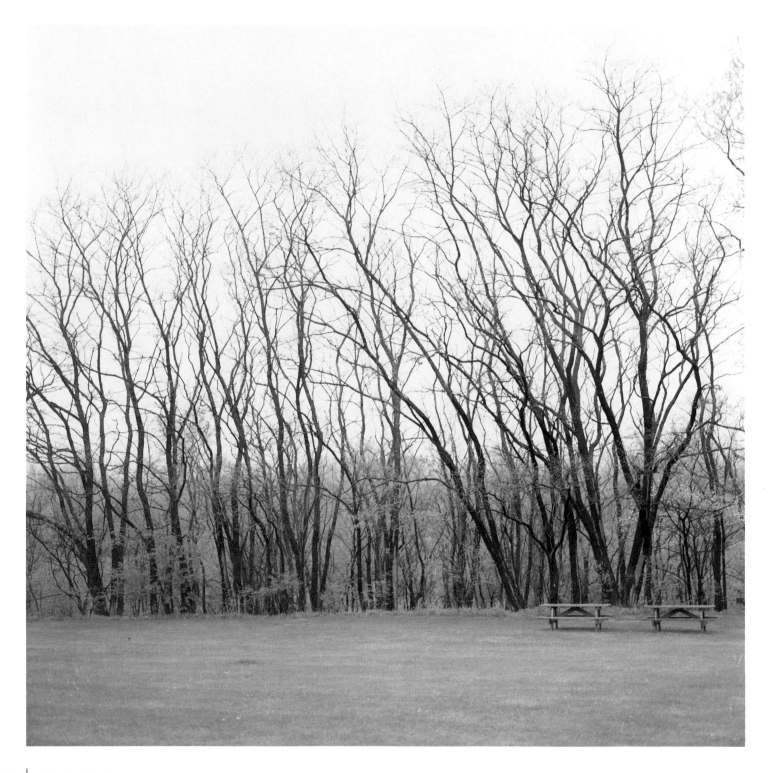

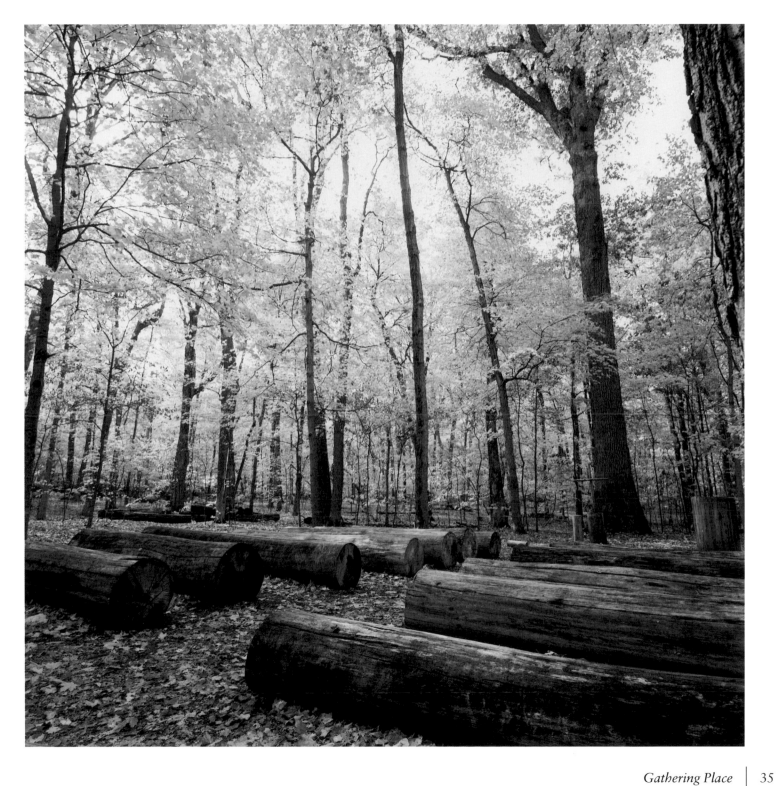

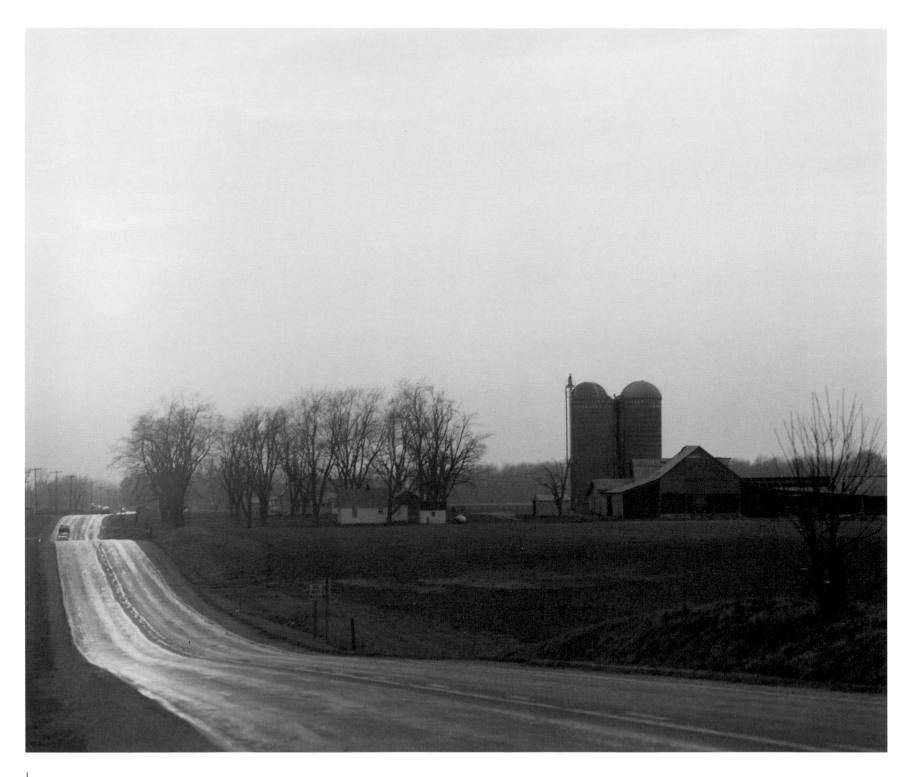

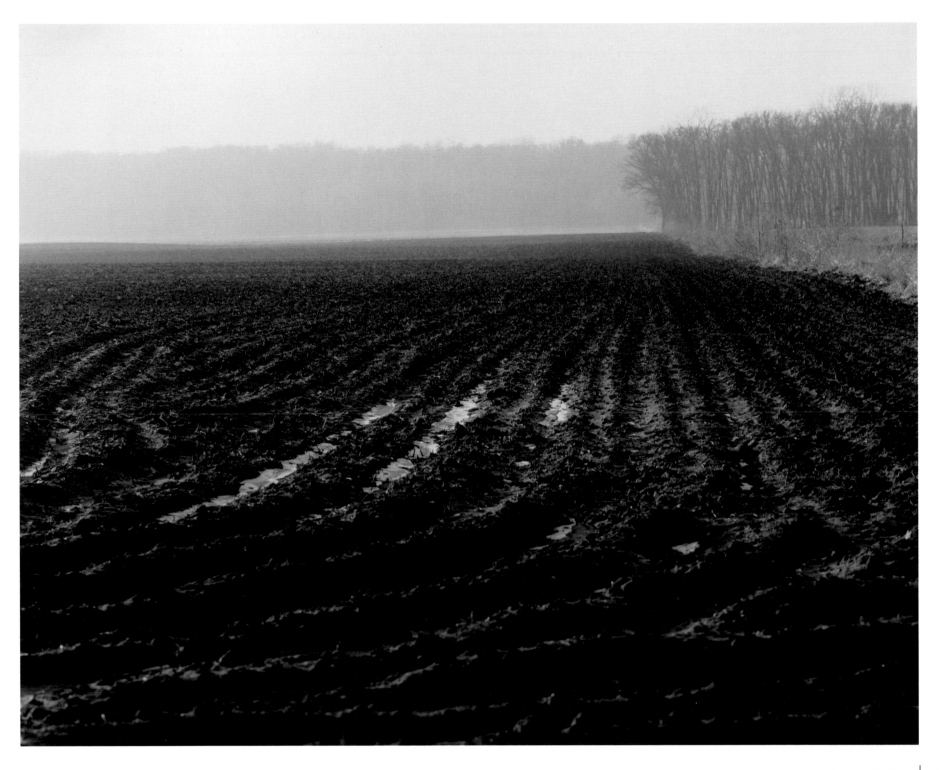

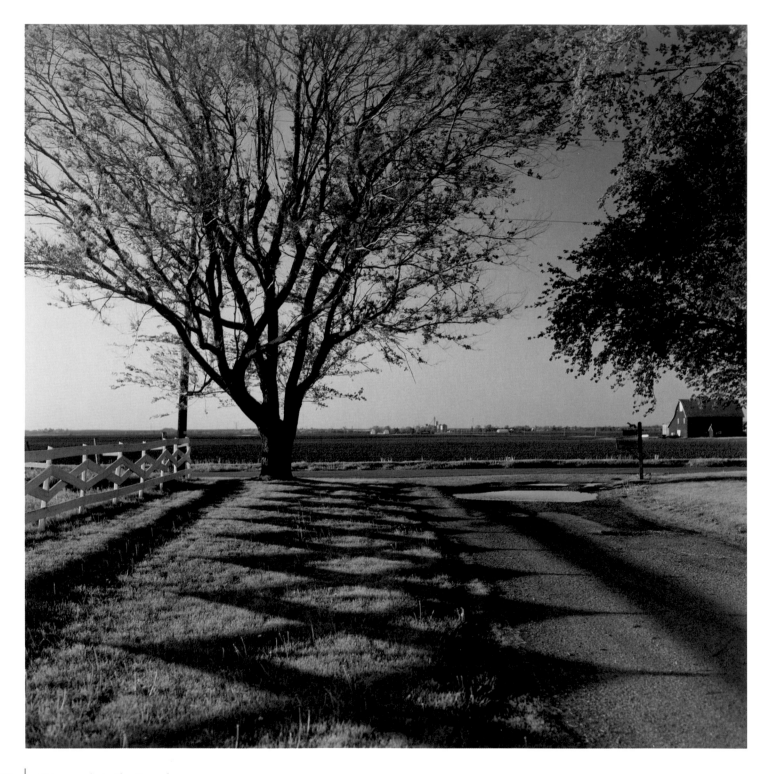

| *Diamonds in the Rough*

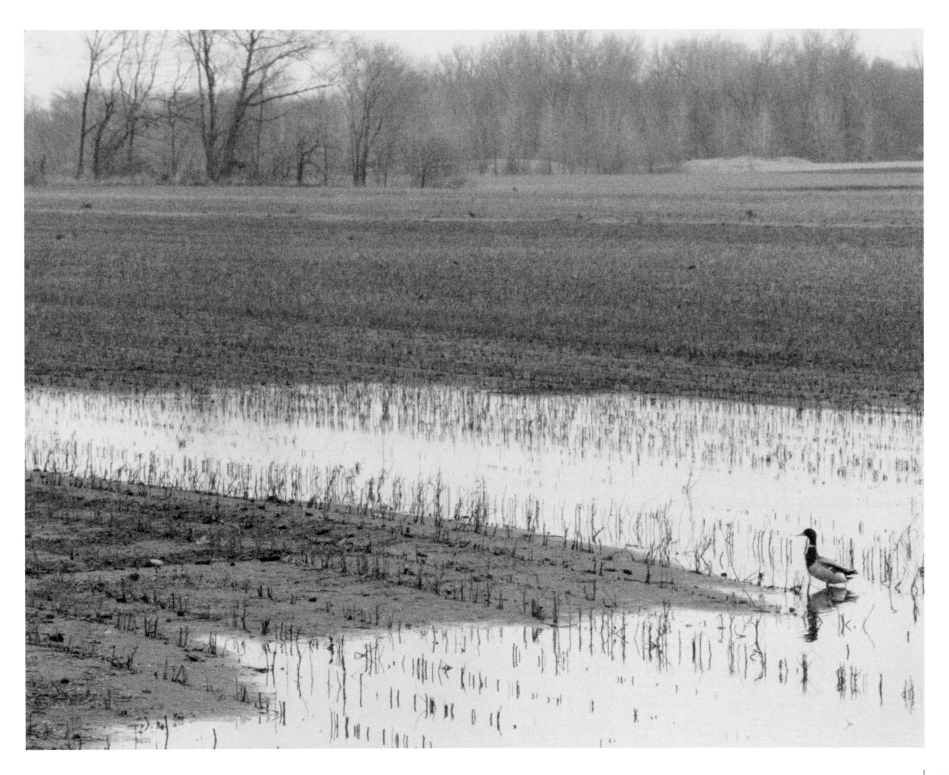

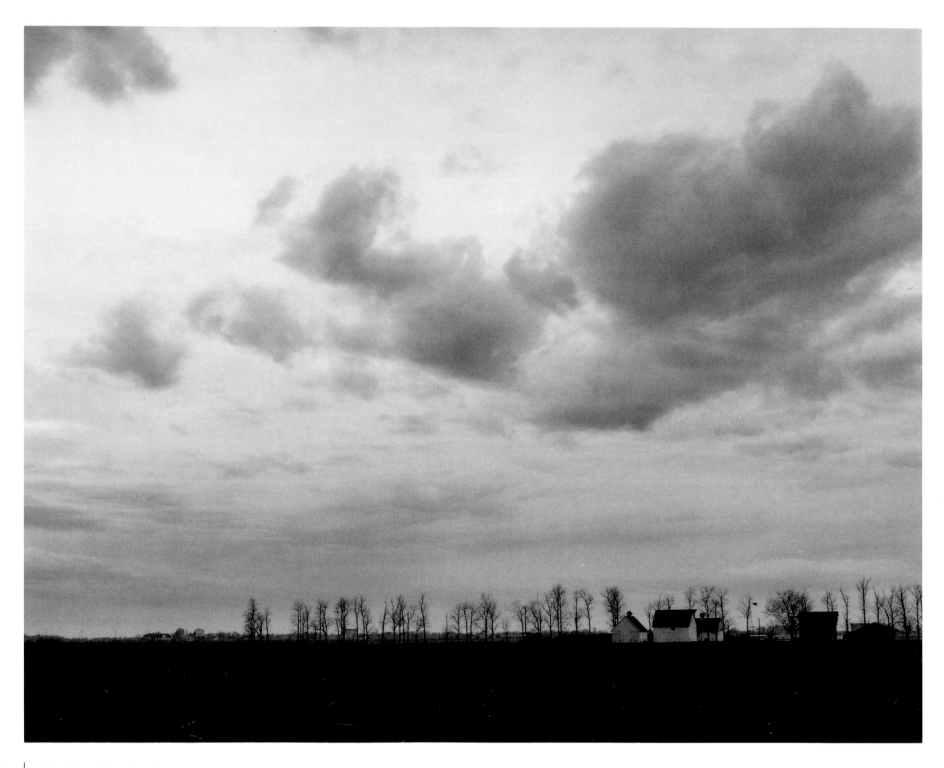

| *New Year's Daybreak*

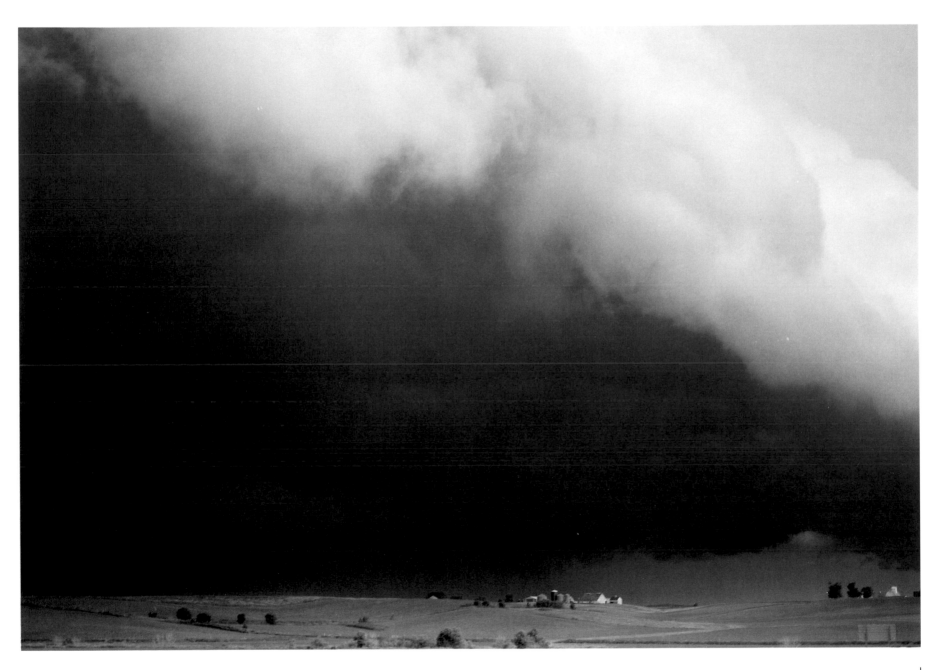

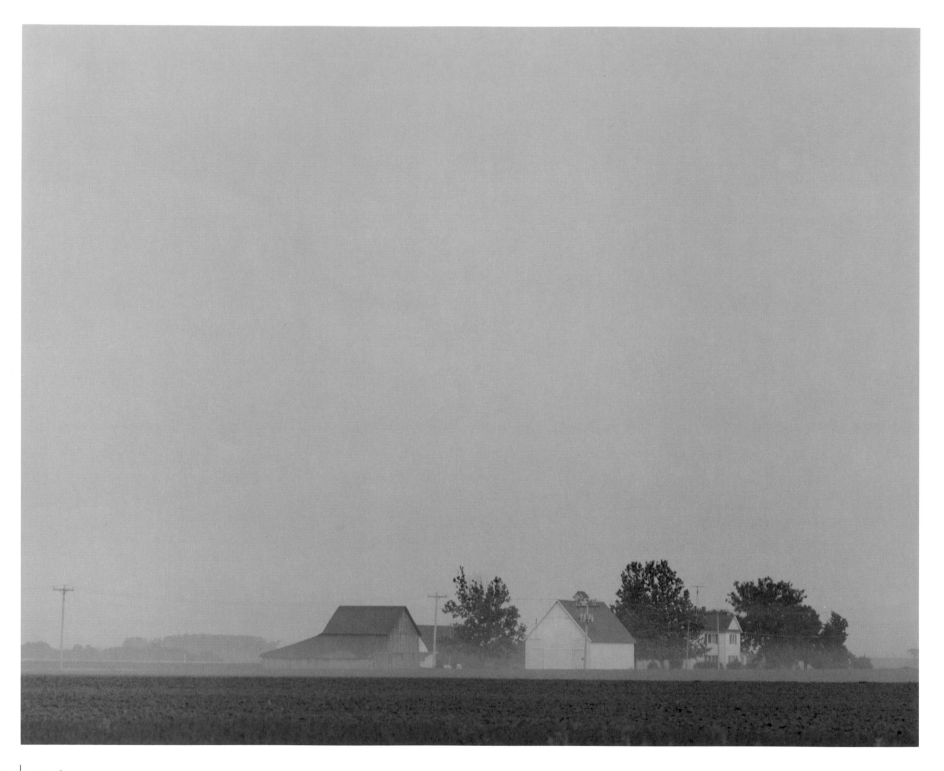

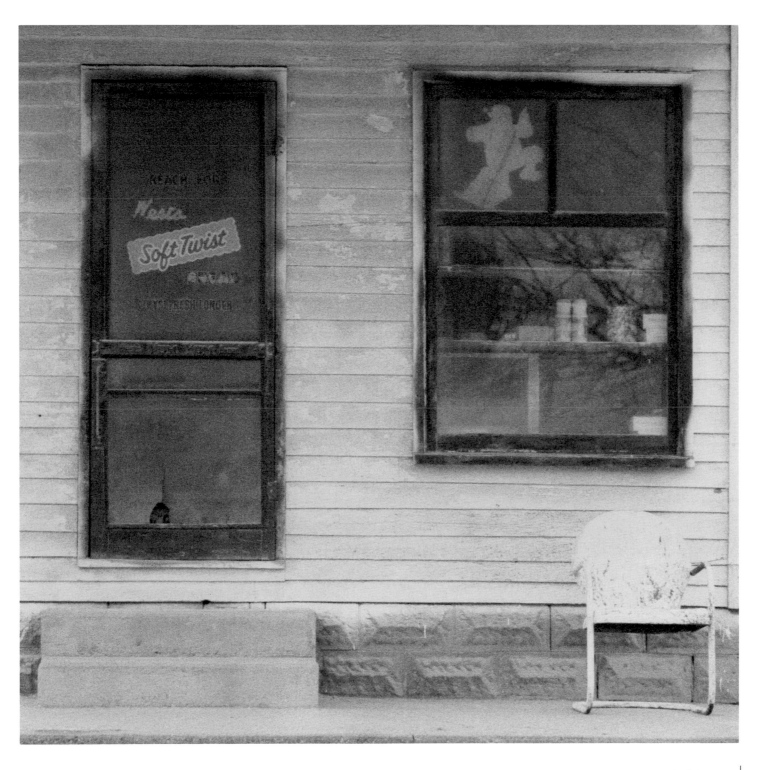

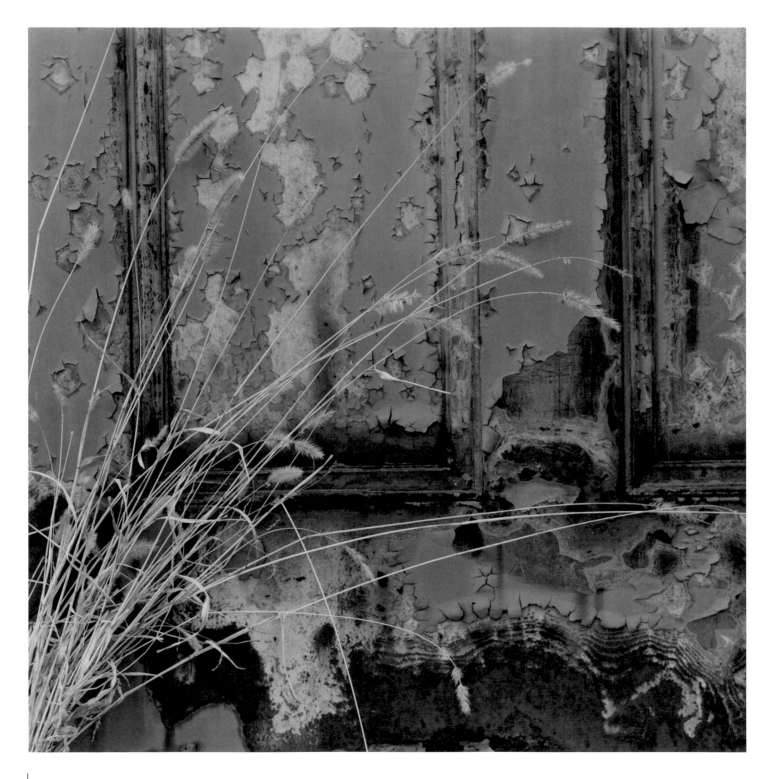

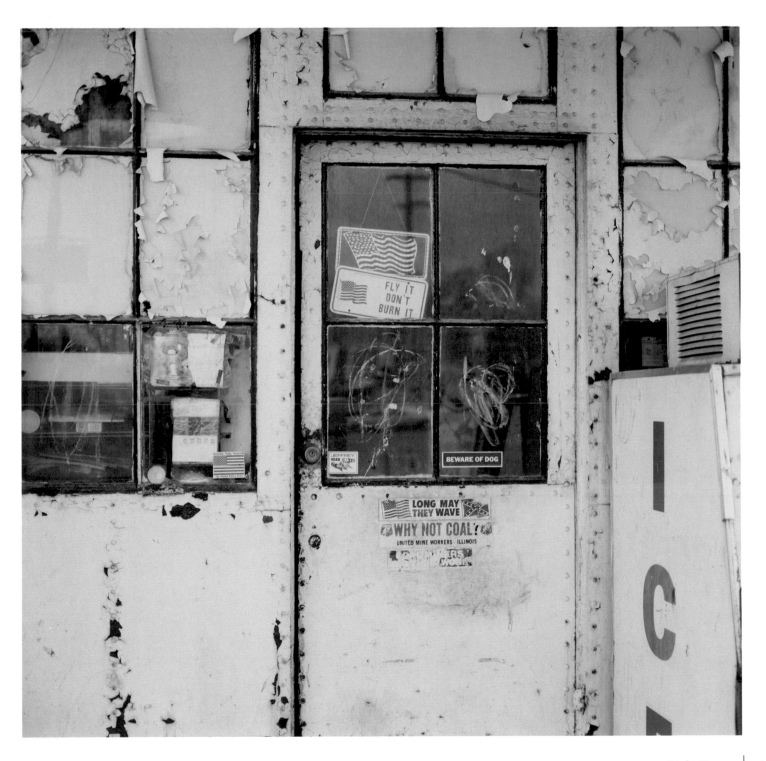

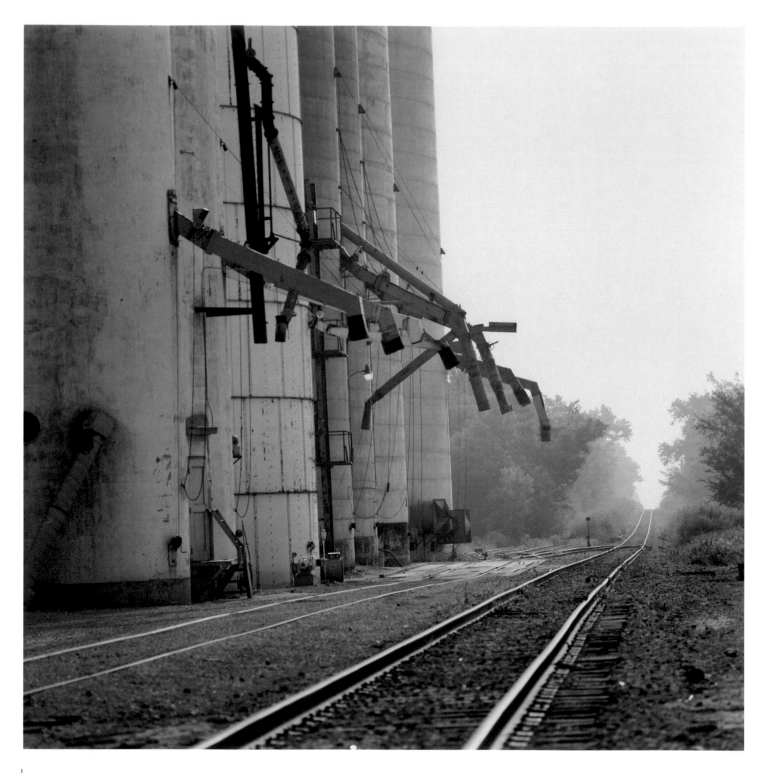

| *Filling Station*

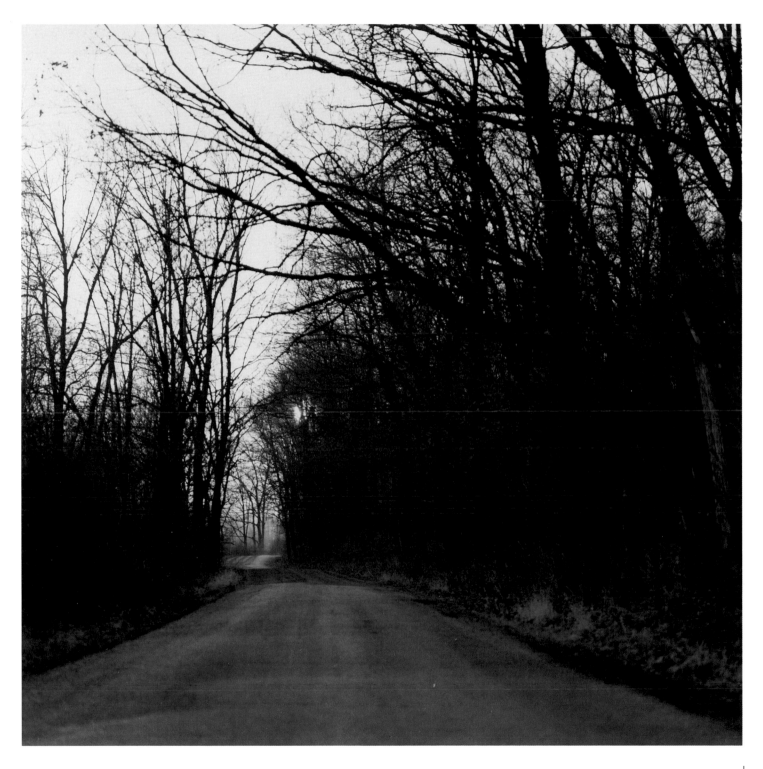

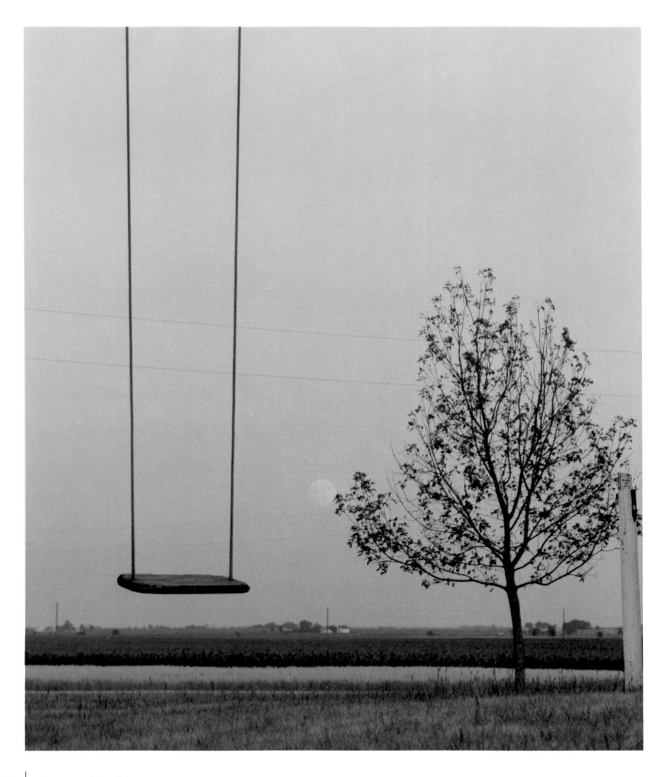

| *Summer Evening*

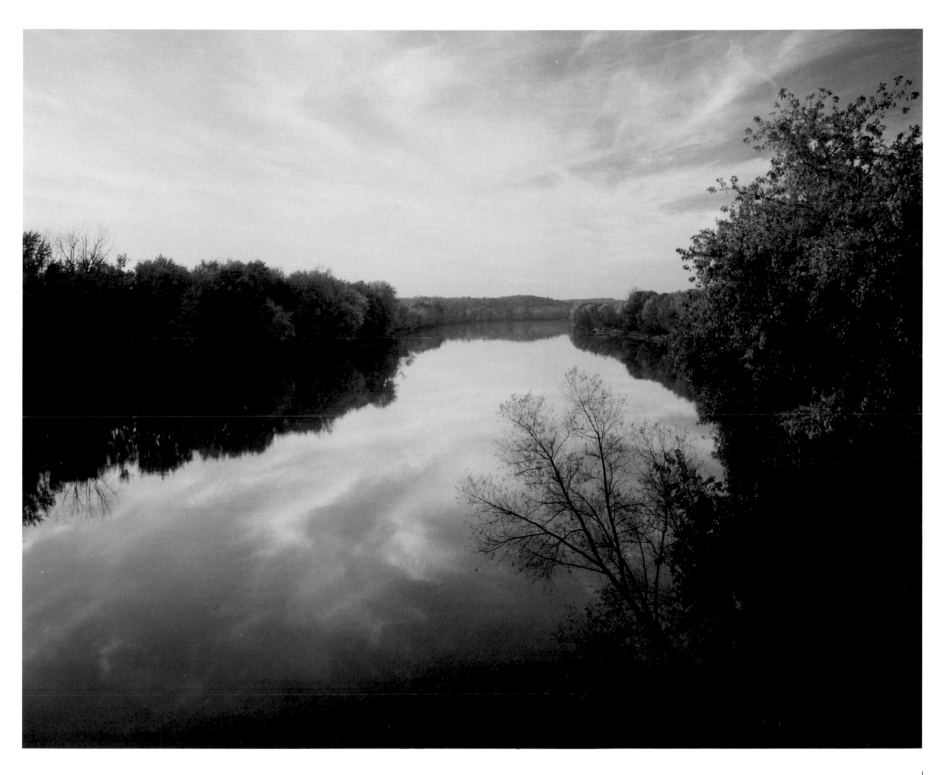

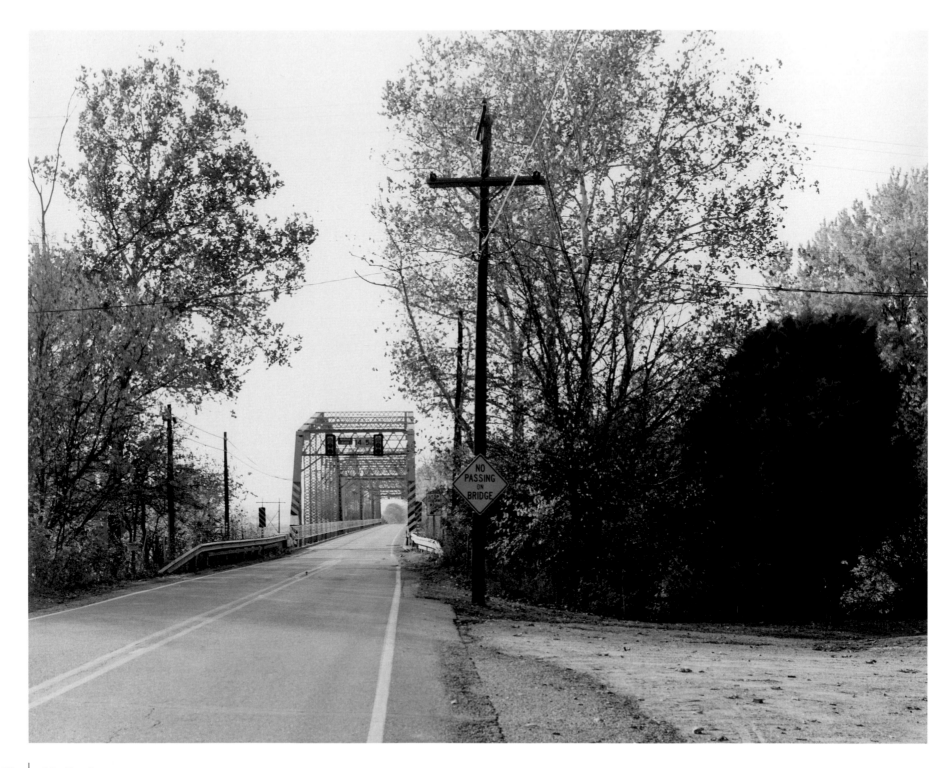

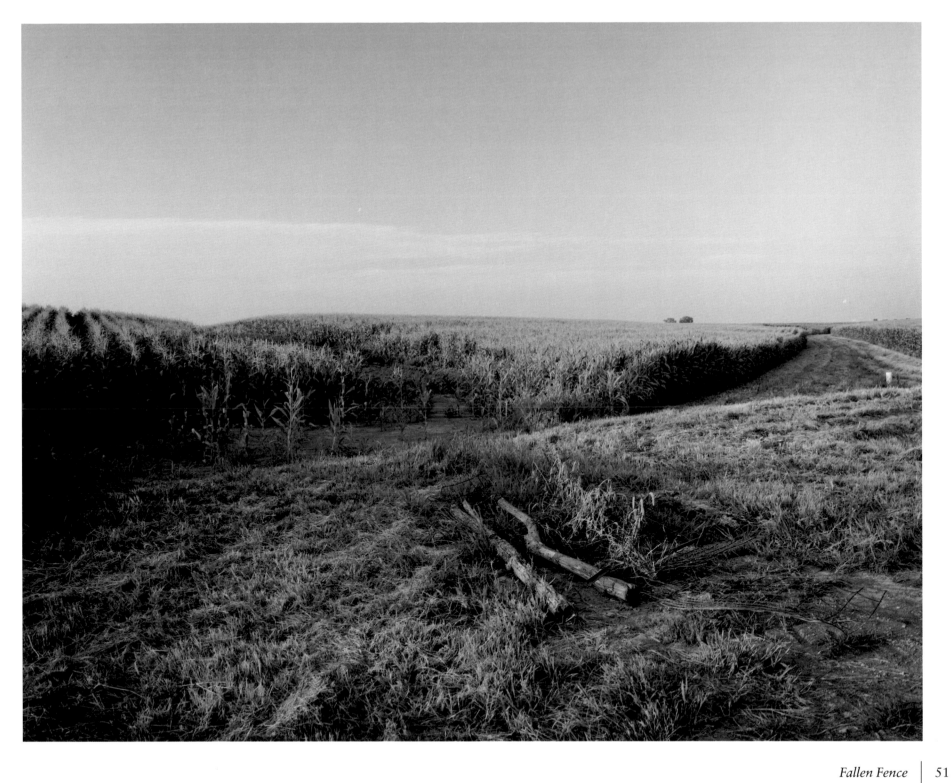

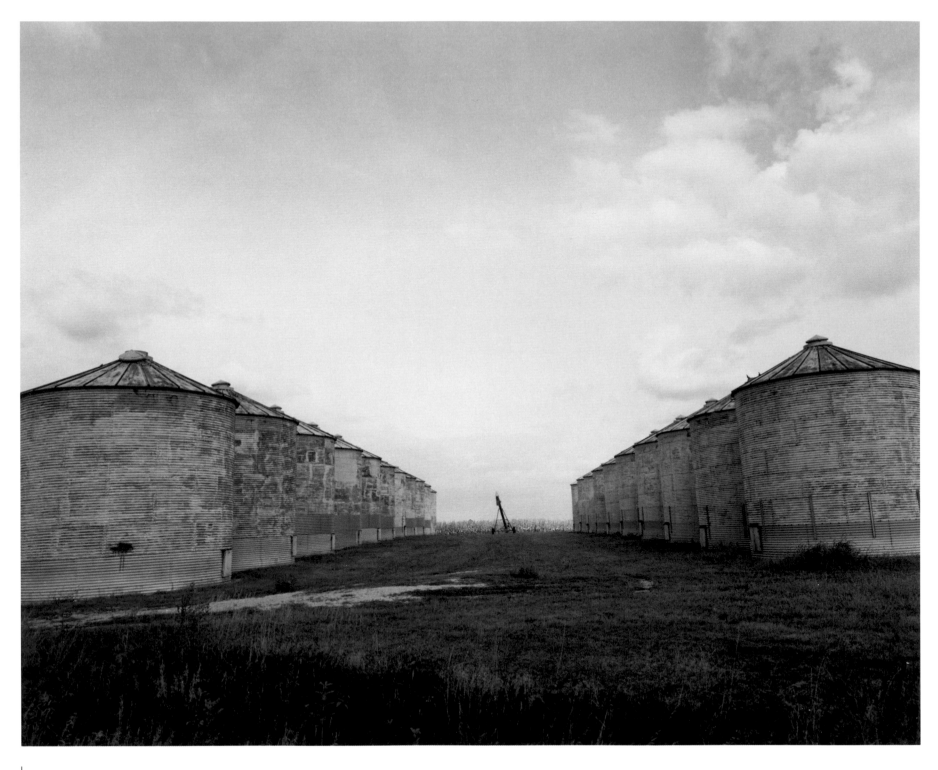

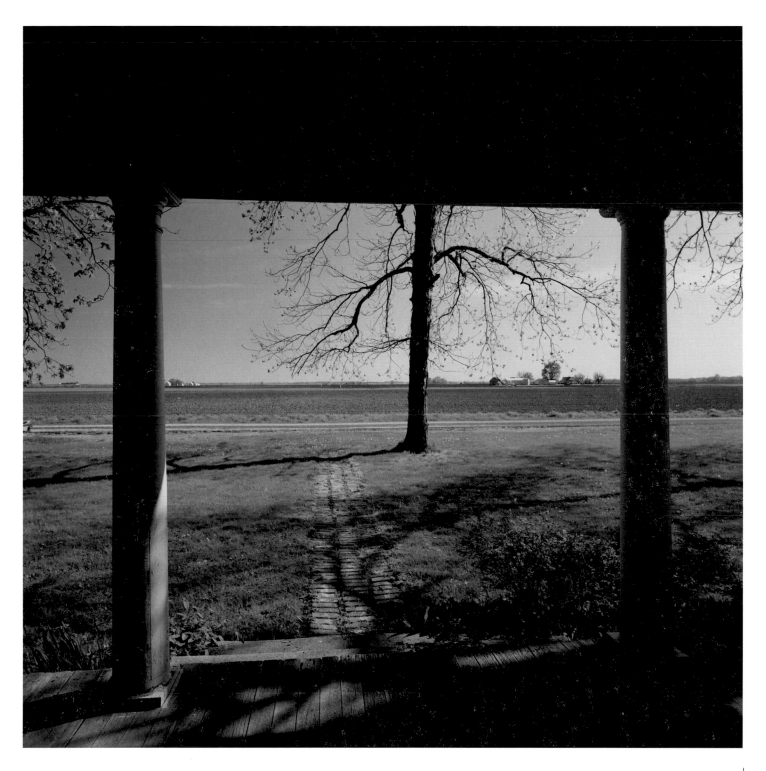

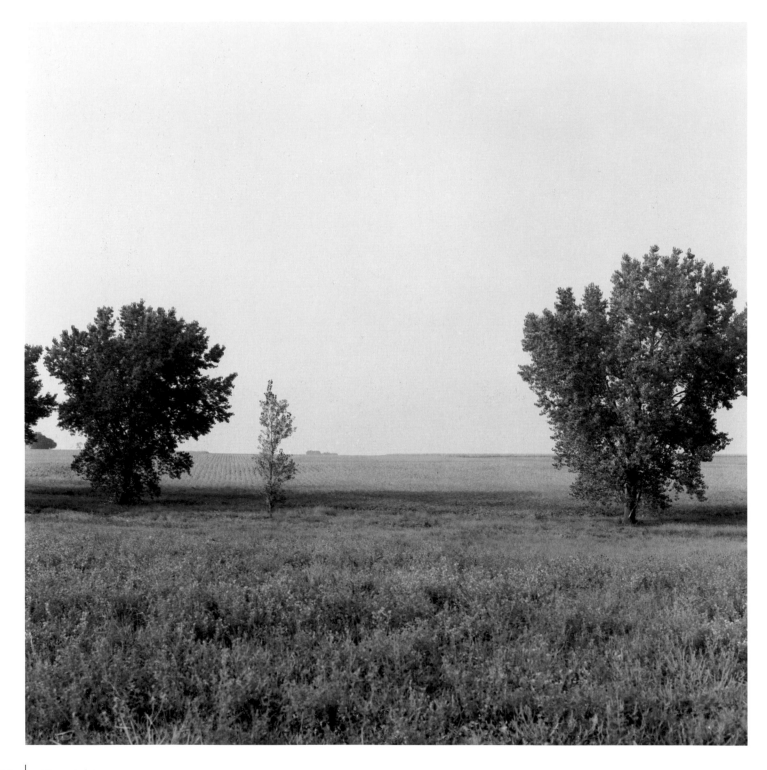

| *Oversight*

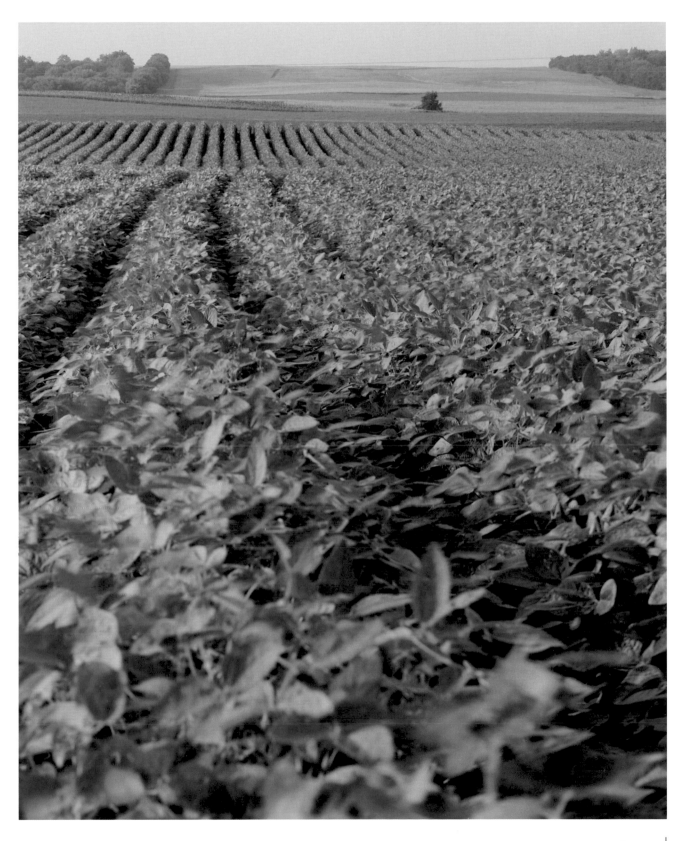

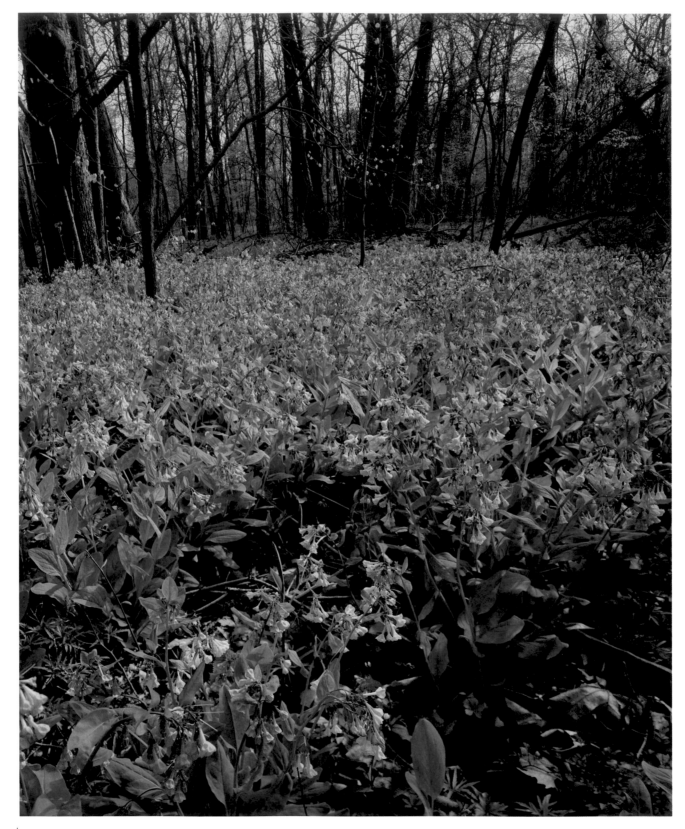

| *Bluebells*

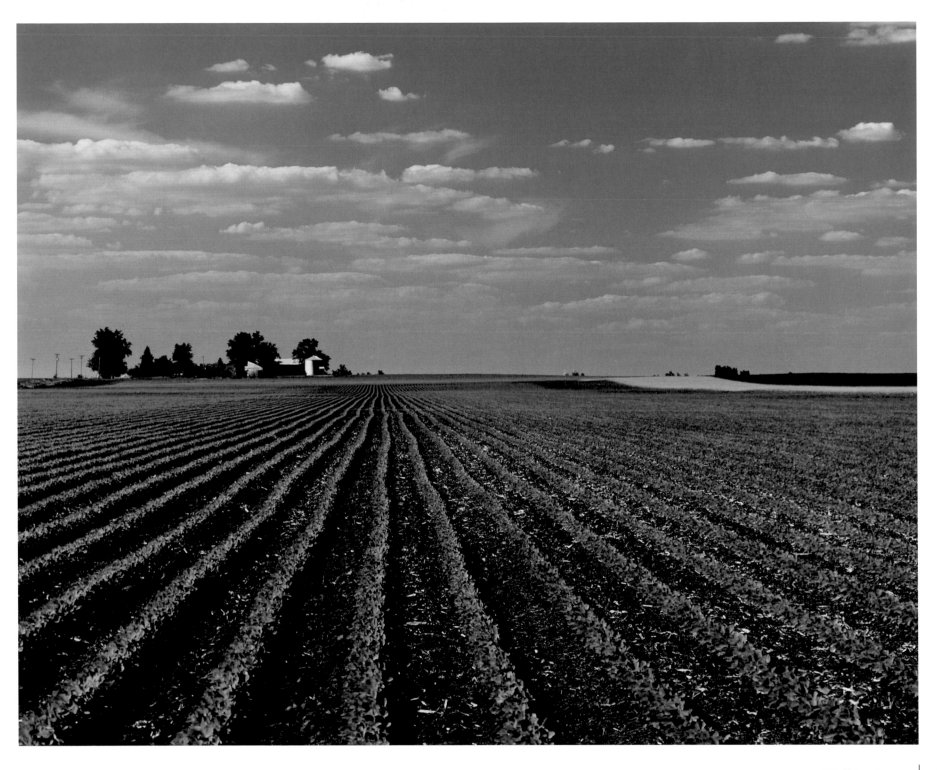

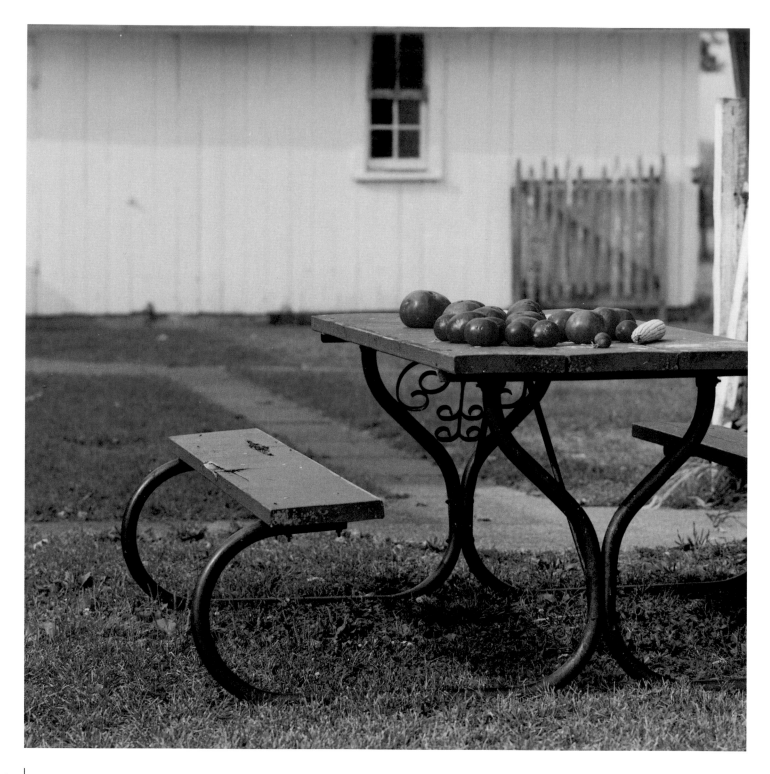

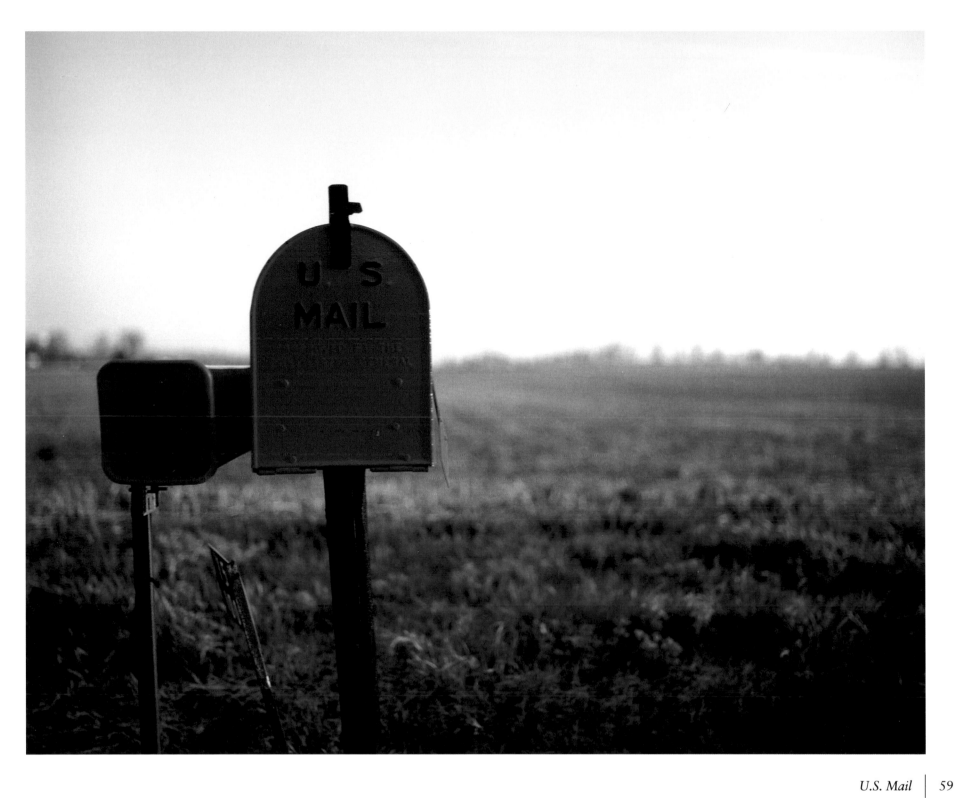

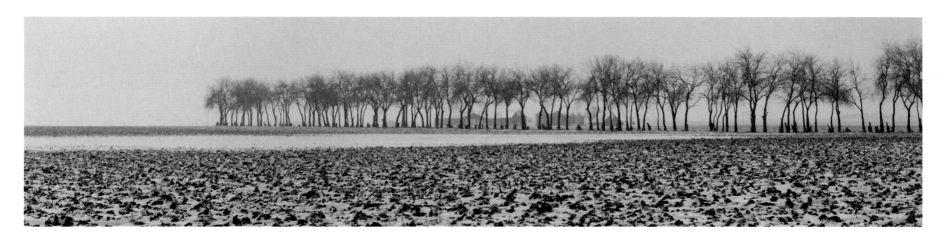

| *Against the Wind*

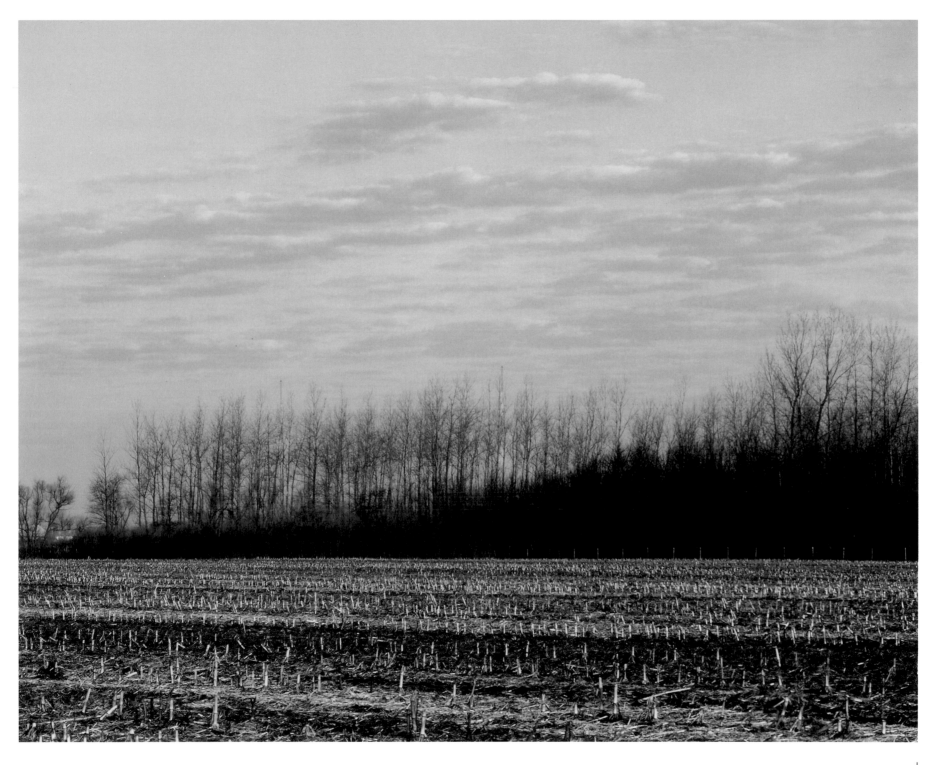

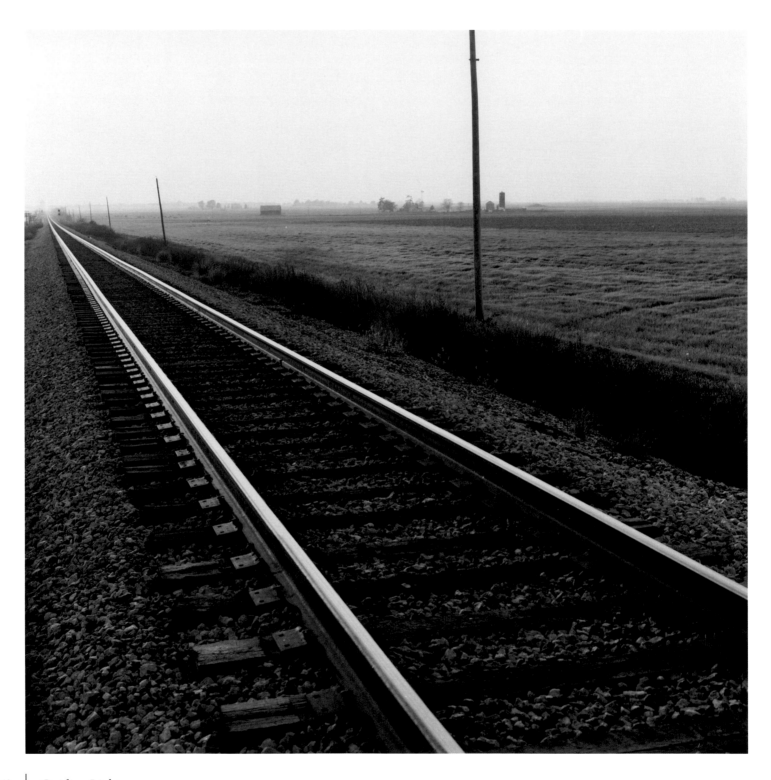

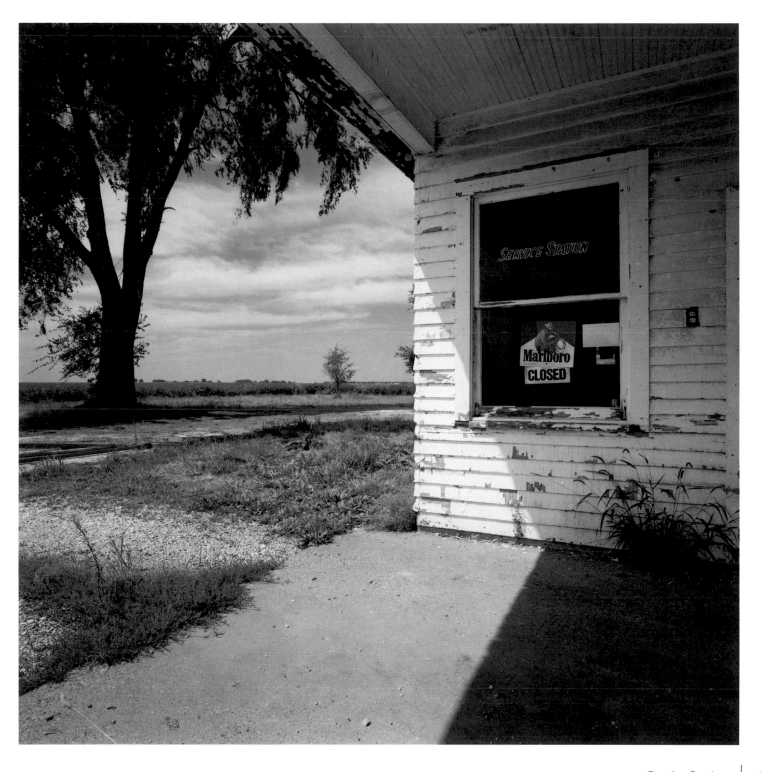

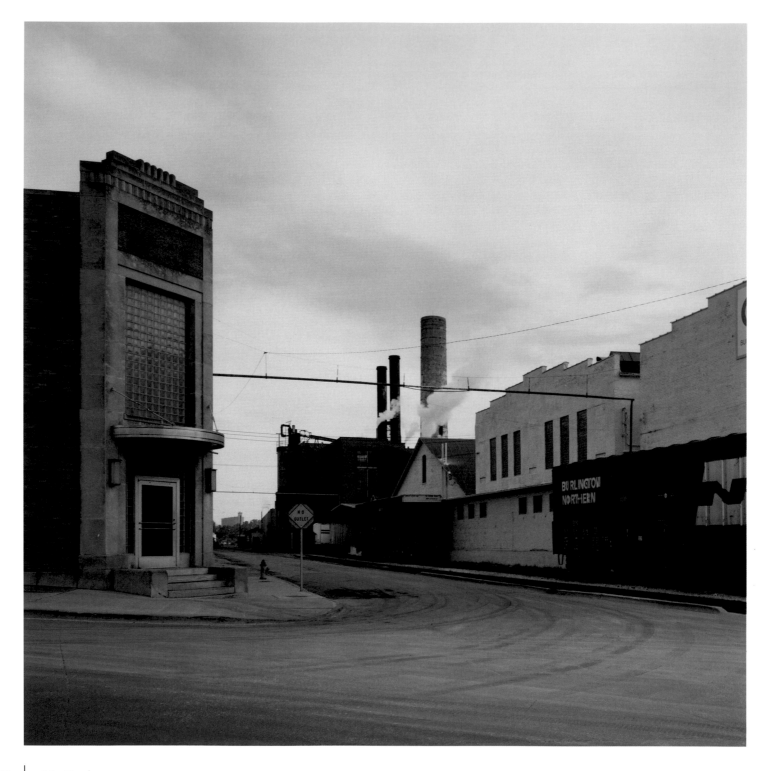

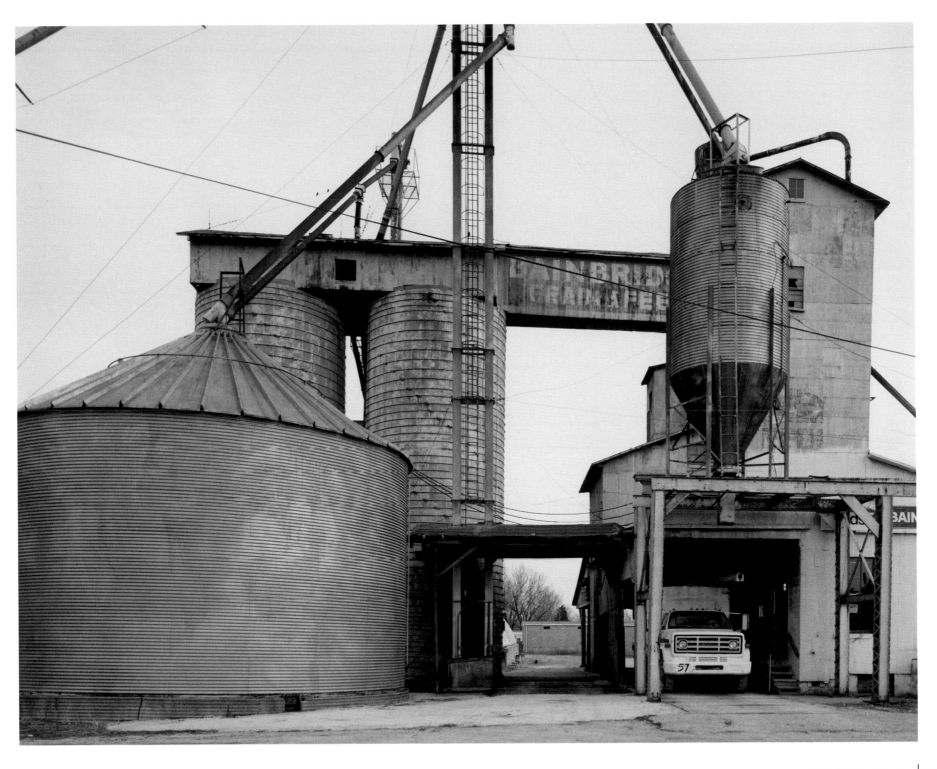

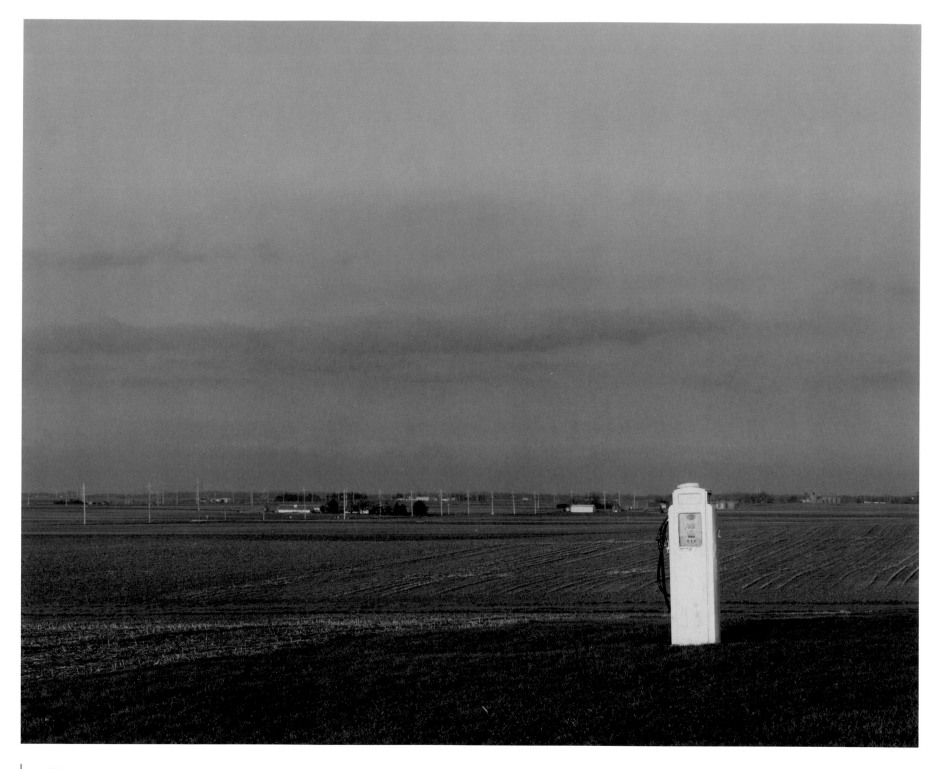

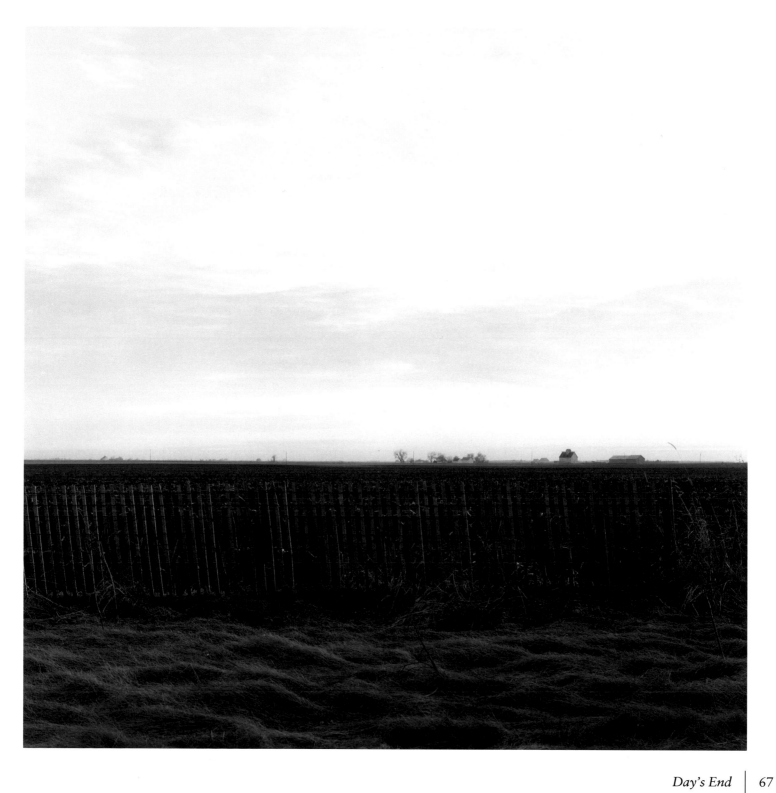

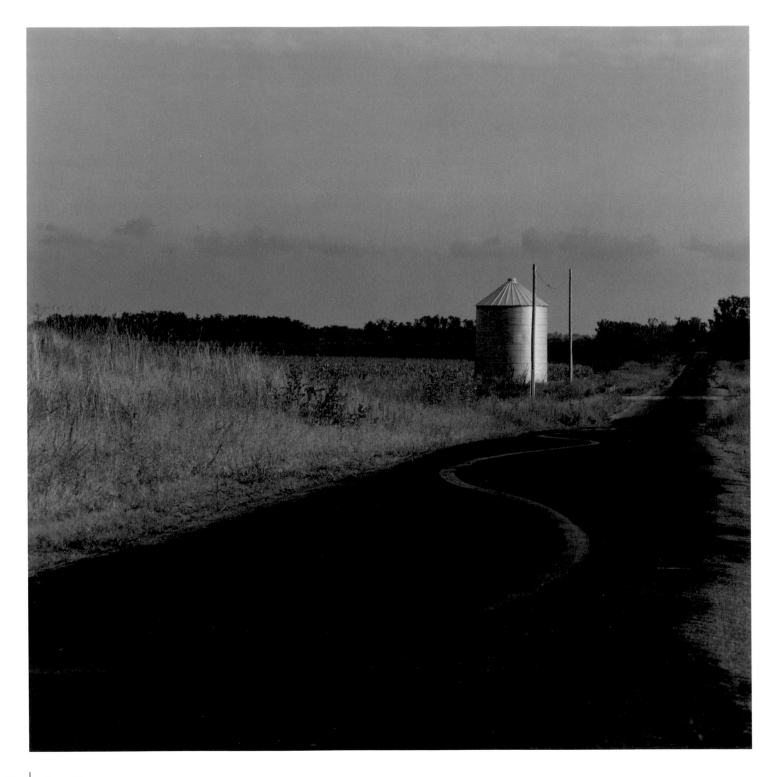

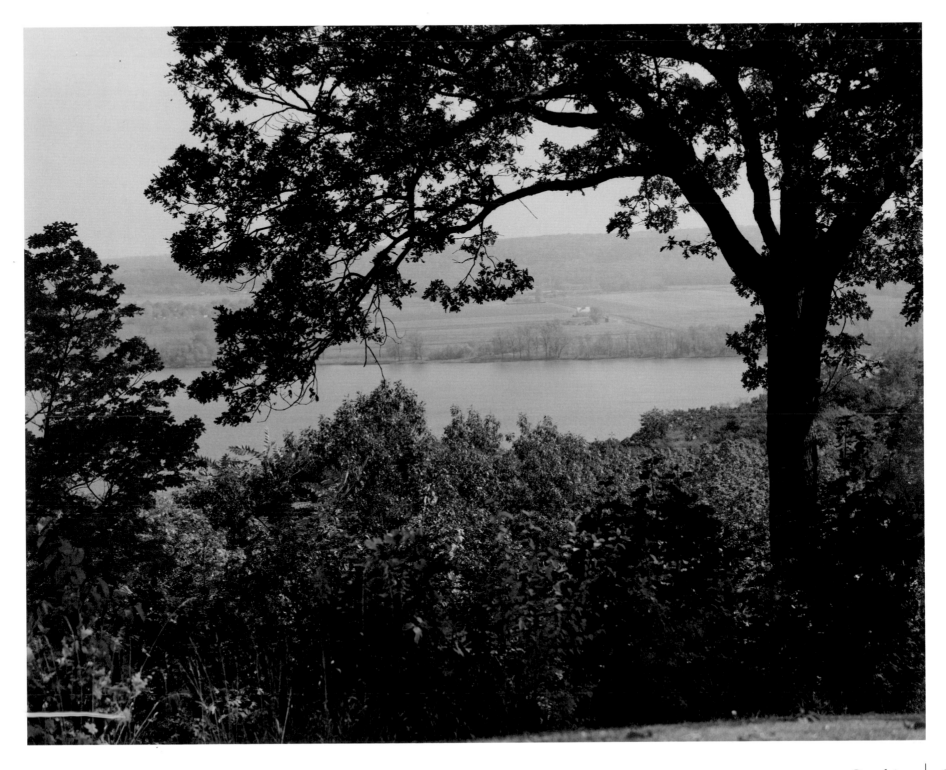

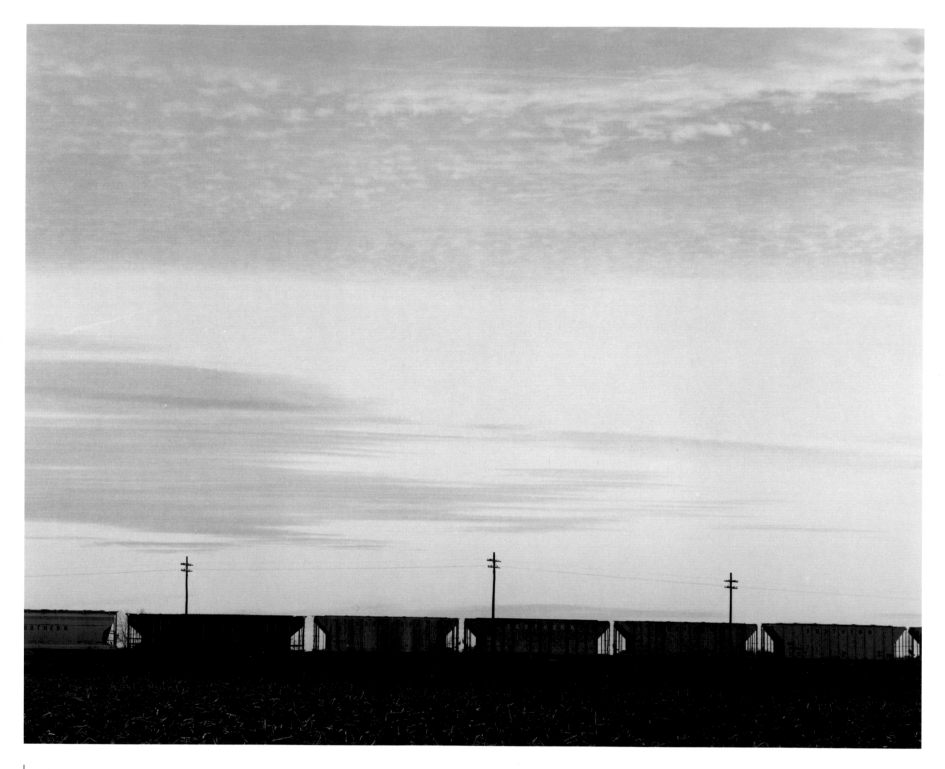

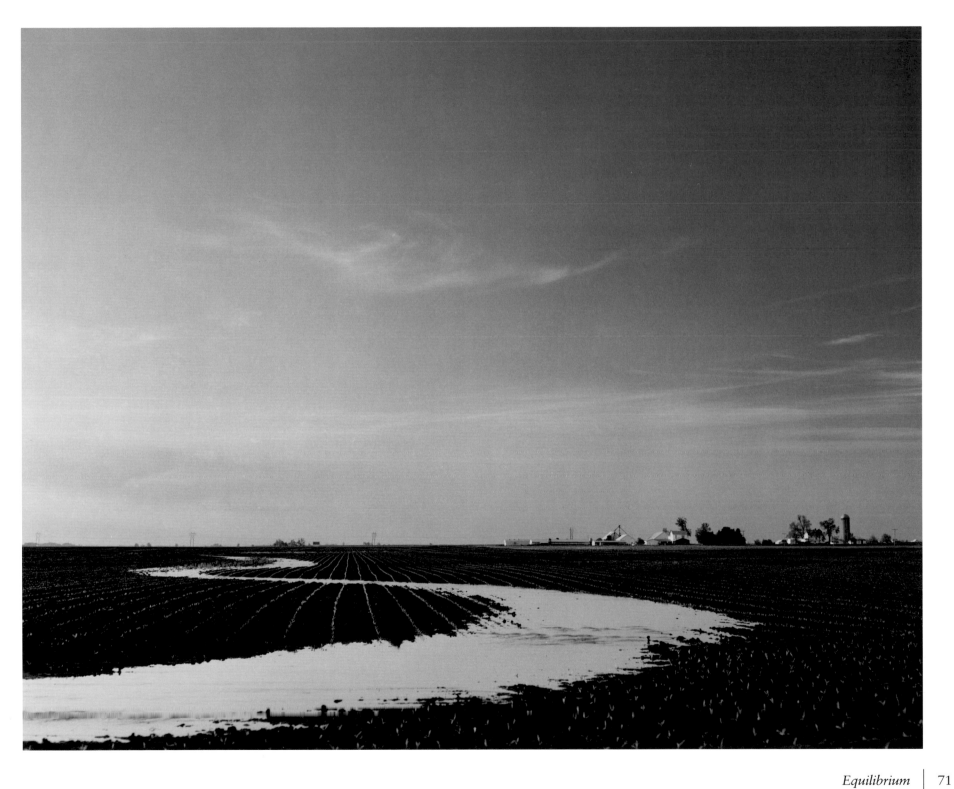

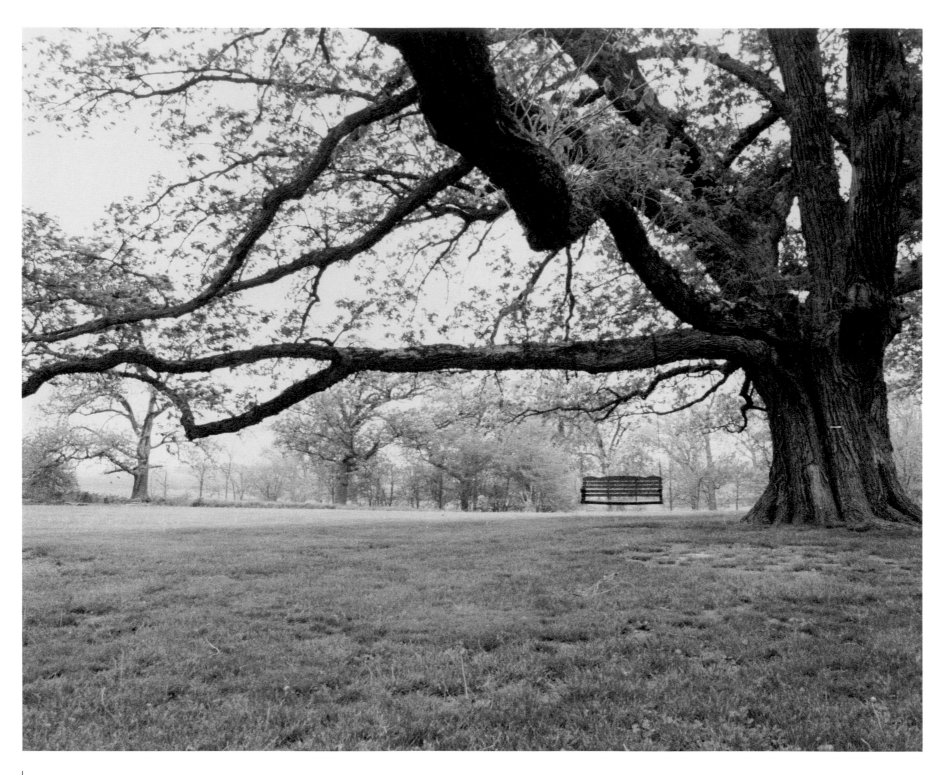

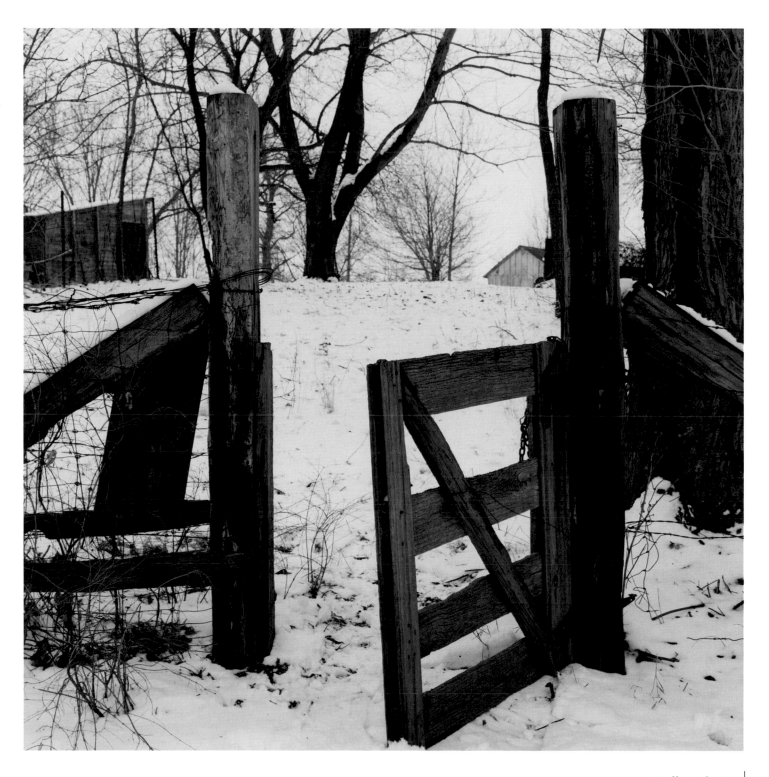

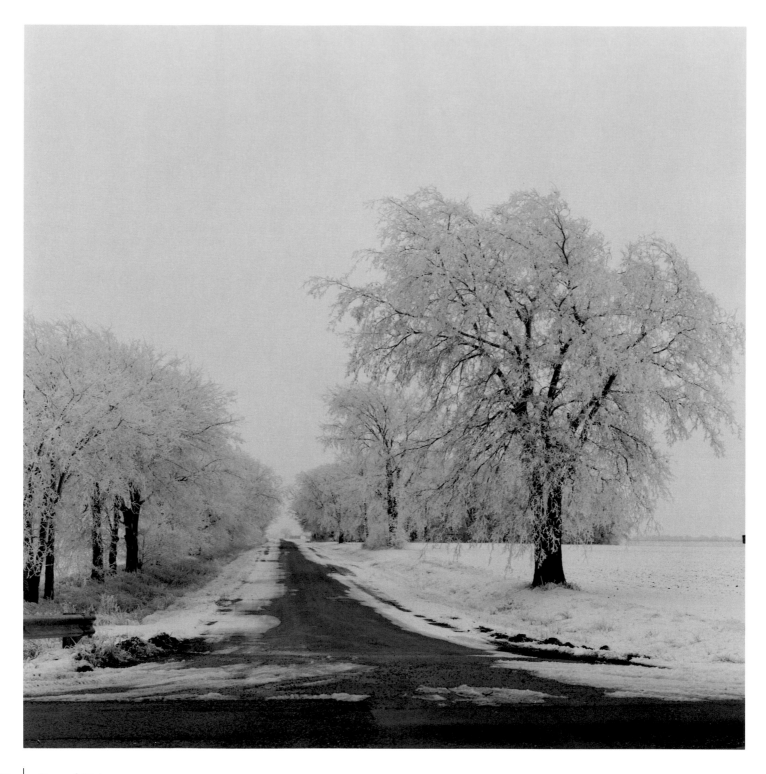

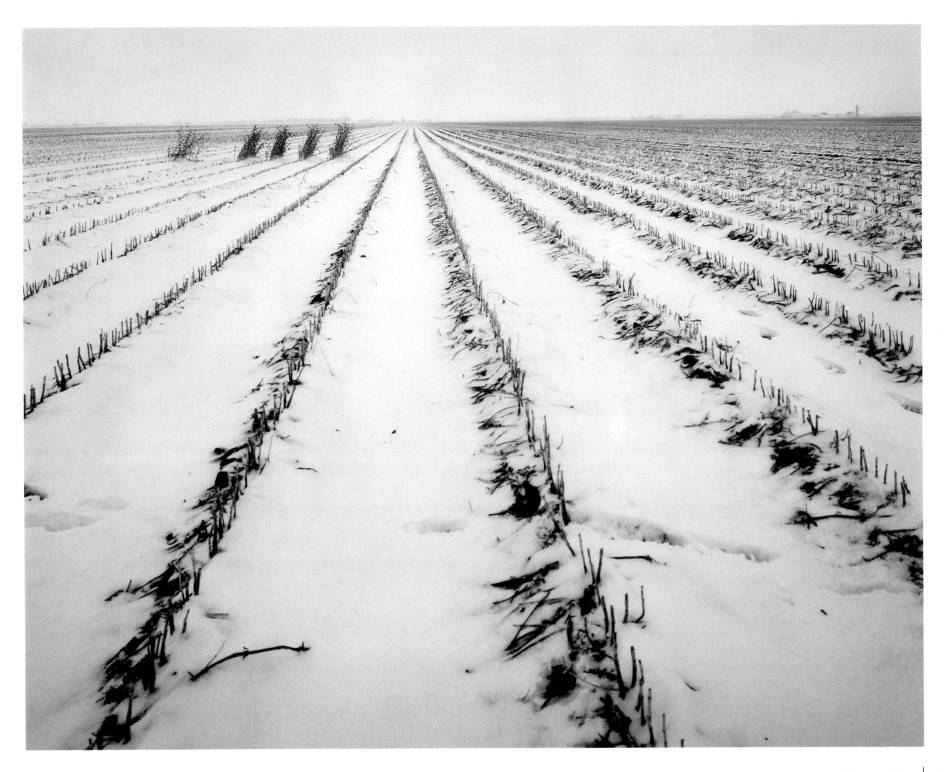

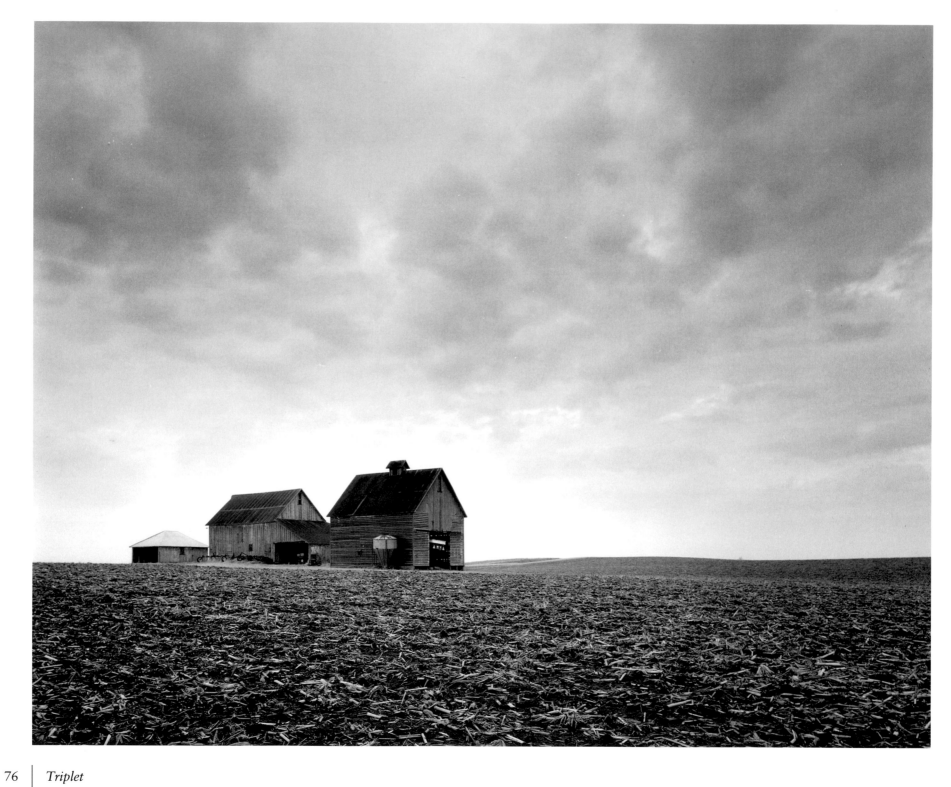

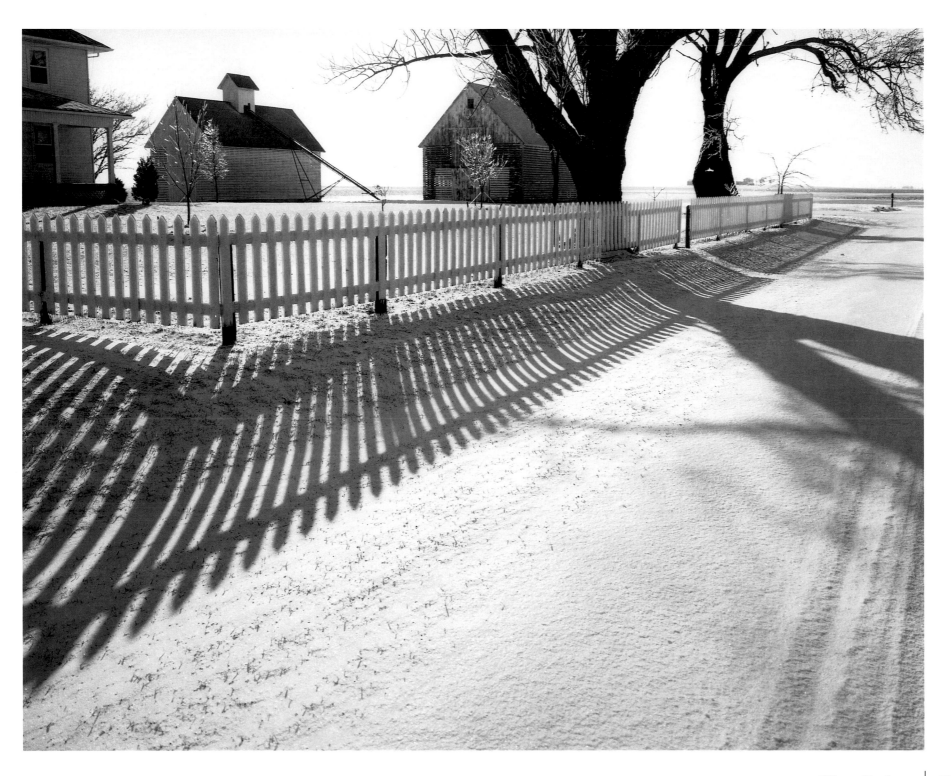

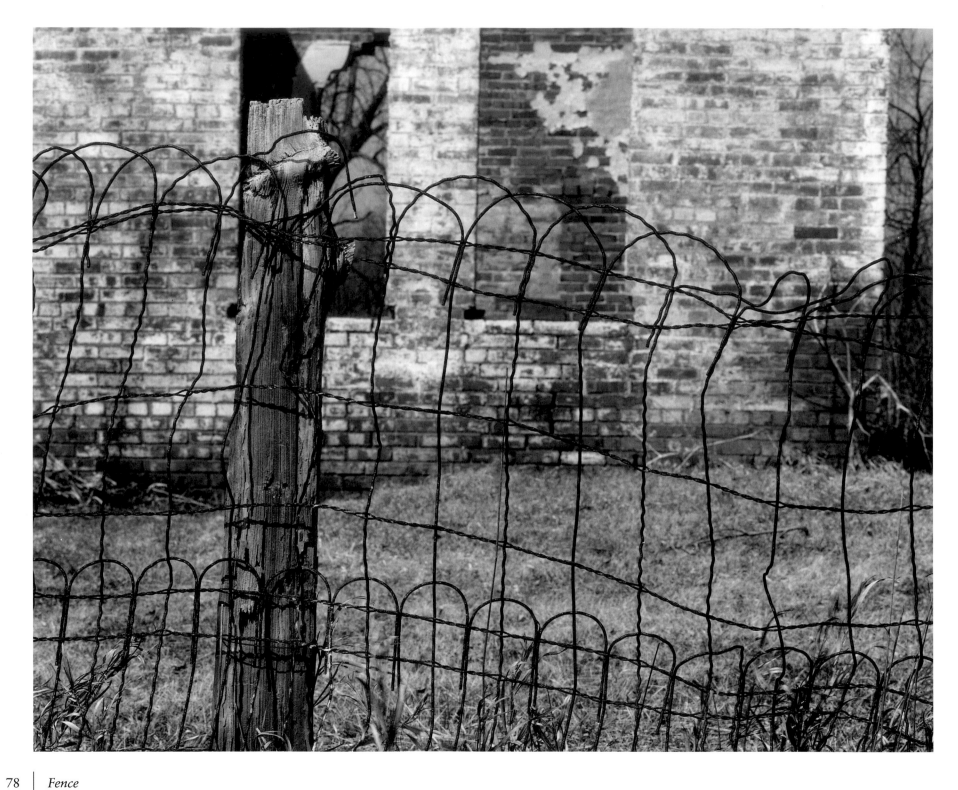

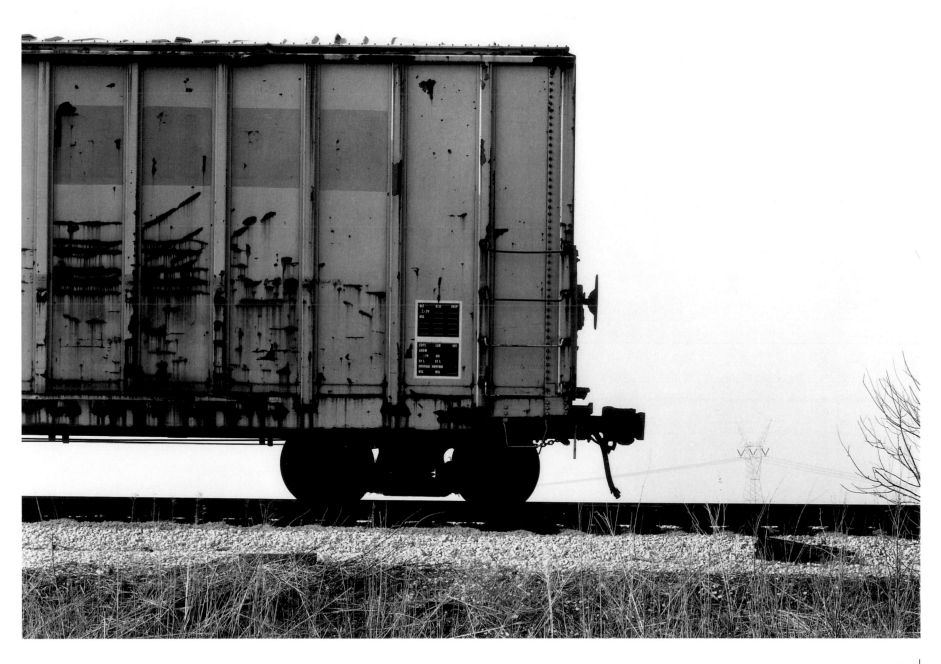

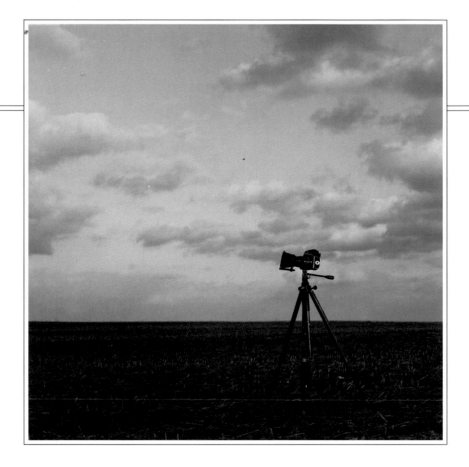

LARRY KANFER is a photographic artist with a studio and gallery in Champaign, Illinois. He was born in St. Louis, Missouri, but spent much of his boyhood in the Pacific Northwest. A resident of the Prairie State since 1973, he has a degree in architectural studies from the University of Illinois at Urbana-Champaign. Kanfer has received several awards of excellence for his interpretive landscape photography, which is carried by galleries throughout the Midwest and on both coasts. He has published two other collections of photographs, *Prairiescapes* (University of Illinois Press, 1987) and *On This Island: Photographs of Long Island* (Viking Studio Books, 1990).

Library of Congress Cataloging-in-Publication Data

Kanfer, Larry, 1956-
 On second glance : Midwest photographs / by Larry Kanfer :
foreword by Walter L. Creese.
 p. cm. — (Visions of Illinois)
 Includes bibliographical references.
 ISBN 0-252-01968-7 (alk. paper)
 1. Landscape photography—Illinois. 2. Landscape photography—
Indiana. I. Title. II. Series.
TR660.5.K34 1992
779′.36773′092—dc20 92-9651
 CIP

Edited by Theresa L. Sears
Designed by Karen Hendricks
Composed in Sabon, with Caslon Open Face display,
by the University of Illinois, Division of Printing Services
Color separations by Andromeda/Flying Color Graphics
Manufactured by Andromeda/Flying Color Graphics